SPORTS
PHOTOGRAPHY

SPORTS
PHOTOGRAPHY

STEVE POWELL
& TONY DUFFY
in association with Keith Nelson

Foreword by Daley Thompson

B. T. Batsford Ltd, London

ISBN 0 7134 3740 5 (cased)

Typeset and printed in Great Britain by
Butler & Tanner Ltd
Frome and London
for the publishers
B. T. Batsford Ltd
4 Fitzhardinge Street
London W1H 0AH

Contents

ACKNOWLEDGEMENT

This book is based on the experiences of All-Sport photographers past and present; we would like to thank them for their contribution. In particular, Adrian Murrell, for his wonderful stories about the trials and tribulations of a cricket tour. Also Keith Nelson for his patience in editing and collating the text produced at odd moments between assignments.

Tony and Steve

PHOTOGRAPHERS' NOTE

Nearly all the photographs printed in the book were originally shot in colour, either on Kodachrome or Ektachrome film. For publishing purposes inter-negatives were made, using Ilford FP4 film and Microphen developer. The negatives were then printed on Multigrade paper, grade 2 equivalent, and processed in an Agfaprint black and white processor.

Foreword

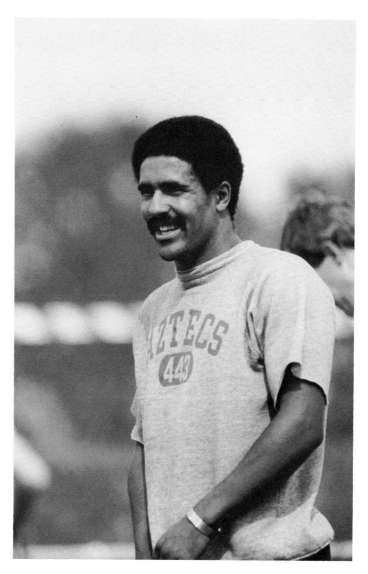

The first thing I would like to say is just how wonderful Steve and Tony's photographs really are, considering their handicaps. As everybody knows, or at least they will after reading this, Steve is colour blind and Tony wears glasses so thick I'm surprised that light can pass through them. Sports' photography is an art, and Steve and Tony have mastered it to a fine degree. Not only can sportsmen, such as myself, look at the pictures and see what they are doing technically, whether it be right or wrong, but Tony and Steve are able to communicate to the ordinary person the whole gamut of emotions that abound during the ebb and flow of competition. To show this as frequently as they do cannot just be a product of luck.

Obviously, the law of averages stipulates that anyone will eventually get a good picture but Steve and Tony do it time after time. This is a product of their hard work, forward planning and Tony's 'mind's-eye'. The work entailed is phenomenal: venues to be prepared, camera angles worked out, weather extremes allowed for, unexpected circumstances taken into account, obnoxious officials placated and long hours endured. Despite all this, whenever I meet up with them they always have time for a laugh and a joke. Last but not least, another of their major talents is to manage all this without being intrusive to the competitor.

Sports photography, unlike some forms of the media, has no 'poetic licence'. It shows exactly what is happening at that precise moment in time with nothing lost in translation. Therefore, down through the years, it has given us a wonderful, living record of great, and not so great, sporting moments.

As you may or may not know, decathlon is my life, but sport is my hobby and once every month or so you'll find me down at All-Sport going through all the new pictures that have been taken by the boys. I hope that you will get as much fun and pleasure from looking at their pictures as I do.

1 *Daley Thompson.*

Introduction

Working with a team of photographers can prove to be a harrowing experience. In the normal course of events, on a newspaper or magazine assignment, the photographer accompanies the journalist to provide visual evidence which complements the written report. But for this book, it was the photographs which provided the essence, with the words built around the pictures and the techniques involved in taking those pictures. And, to complicate the arrangement, it's not just the work of one photographer that's being considered, but several.

It was not always easy to get hold of those concerned, particularly during the summer. In the period immediately prior to the completion deadline of this book, one photographer was in America for an extended period, another was to-ing and fro-ing to Wimbledon for the Lawn Tennis Championships, while others were charging around the country to capture seemingly every ball bowled in the cricket World Cup.

One of the fundamental aspects of sports photography is that it's not a nine-to-five occupation. In a society increasingly geared towards the massive sports and leisure industry, more and more sports events are taking place in the evening and at weekends, particularly Sundays. And there is a growing number of them. Recording these events with a camera has become less of a job and more of a lifestyle.

Sports photographers are like sportspeople: the more they put in, the more they get out. There are no real short cuts to success in this particular field of photography. You can have all the techniques and equipment in the world, but if it's a rainy day, there's not a lot that can be done about it.

The question of style is an important one. In talking with and listening to All-Sport photographers, their differing approaches are clearly evident. Tony Duffy is a sports fan, turned photographer, whose passion lies in the recording of line, extension and form. Steve Powell favours the action-packed events, while Adrian Murrell follows the MCC on tour for three months every year. That's not to say that the photographers aren't equally at home at any sport, it's just that, working on an agency basis, there is room to allow the individual photographers to work more in certain fields, to give fuller expression to their own specialised talents.

There is a deliberate intention in this book to get away from the basic 'how to' type approach. While these are very useful to get to grips with a subject, it was felt that the basics have been written on sufficient occasions without another volume to swell their ranks. This book, therefore, attempts to share the usual, unusual, sublime and ridiculous approaches the sports photographer sometimes employs to take pictures of his subject.

Before working with All-Sport, I had a pre-conceived notion about sports photographers and their work. I now have none at all. Why? Because each job is so different, requiring the photographer to vary his technique and try out something new. While there are always the straightforward assignments, each must be tackled in a particular way.

To many, the sports photographer's life

must appear to be a glamorous one, with frequent trips abroad, photographing the world's finest athletes. All-Sport's personnel have certainly travelled more widely than most others of their generation. At the same time, it's a lot of hard graft, coping with all the travel and with local conditions. As well as the photographers, a back-up team is also important. Behind the scenes, a considerable staff is needed to run the business side of things: keeping the darkroom going, with thousands of slide duplicates required for distribution to the world's press, and the library itself, brimming with close on a million transparencies.

Keith Nelson

2 *Take your eye off the ball and focus on some of the complementary aspects of the game. Tony Duffy's shot shows the excitement of the Czech ballboys when their hero, Ivan Lendl, had just won a critical match.*

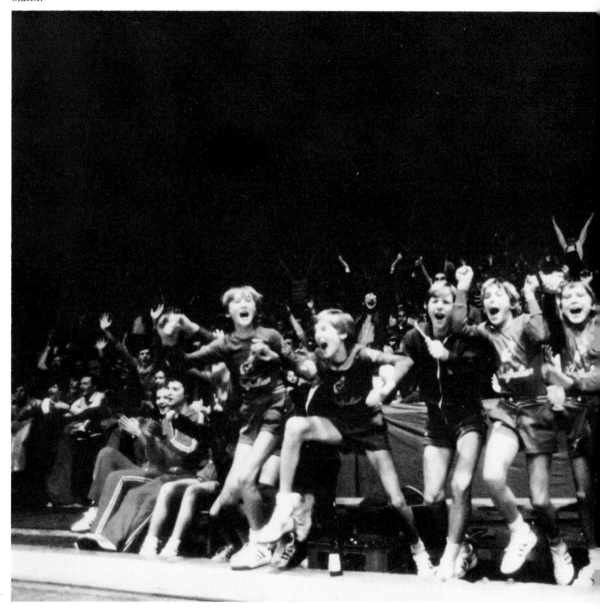

1 Breaking the Rules

The output of sports photographers around the world is staggering, not only at the major events with a bevy of international stars but also at club and school level. Where there's sport, there are photographers. Take, as an example, a typical sports meeting with ten serious photographers in attendance. Each one shoots off ten rolls of film. That makes a total of 100 rolls of film, or 3600 pictures in one afternoon's work. Out of that total, less than one in every 100 is likely to be published – or, put it another way, only 36 out of those original thousands. That's a pretty demanding marketplace.

Certain basic guidelines have been spelt out in every elementary text book on action photography: shoot with the light behind you; use a fast enough shutter speed to stop the action; use a 200mm lens or longer to focus on the action; concentrate on the winner (if you want to make money!). These and other basic rules are, however, nothing more than an extension of common sense and a working knowledge of the technical capabilities of your camera equipment.

What is it that makes one sports photo stand out from amongst thousands of others taken at a similar event? The answer is simple enough: a willingness to break the rules. Not on every occasion, not all the time, but with some forethought and a gambler's instinct of the way the cards might fall. But how are the rules broken? Here are our *eleven* commandments for going against the grain.

1 TAKE YOUR EYE OFF THE BALL
A good photographer is totally aware of

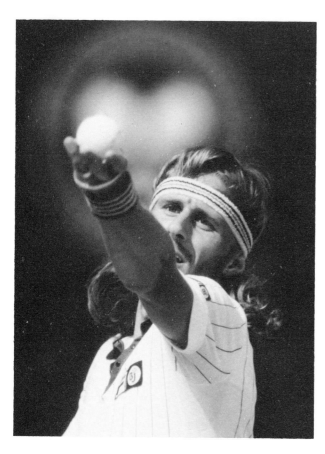

what is unfolding in the sports arena. This doesn't just consist of the man about to score the winning goal or the first horse crossing the line at a major race. While these are critical elements, the photographer must be aware of the action and re-action of opponents, colleagues or officials and, especially, spectators who can often provide an equally convincing and, in some cases, a better record of the moment. The greater the photographer's awareness, the more scope he has at his fingertips for exploiting these various elements.

Sometimes, necessity is the father of invention. Consider a penalty kick during a football match. It's man to man, kicker against keeper, and the best bet is usually a slightly wide lens, to cope with the ball going to left or right. But what happens if you're caught at the wrong end of the pitch? This happened some years ago, for a vital penalty during a cup match. The photographer in question was at the far end of the pitch and obviously had no time to race to the other end to get behind the

goal to be in the right position for the shot. The picture he obtained, however, from the wrong end, scooped the pool. It showed the goalkeeper of the side taking the penalty with his head in his hands and his back to the kick at the far end of the pitch – he was so nervous that he couldn't bear to watch. Out of this seemingly impossible situation, the photographer's awareness enabled him to capture a rare shot.

It takes a lot of courage deliberately to turn your back on what could be an historic picture. Let's look at Duffy's photo of the ballboys leaping for joy. The occasion was the moment of victory in Eastern Europe's first ever Davis Cup win in Prague, 1981. Ivan Lendl, the Czech number one, was winning his deciding match quite comfortably. He is a very undemonstrative player, unlikely to perform tricks for the camera – not someone to sink to his knees, jump the net or hurl his racket into the crowd. As the match points drew closer, the ballboys (all Czech junior players) were leaping up and down as each point was won, barely able to control their excitement. At match point, a wide angle lens was fitted on to the camera and turned away from the court. The result? The classic photo of leaping youngsters. The picture was run as the opening double spread for a feature on Czech tennis for which the photographer had been commissioned (*Fig. 2*).

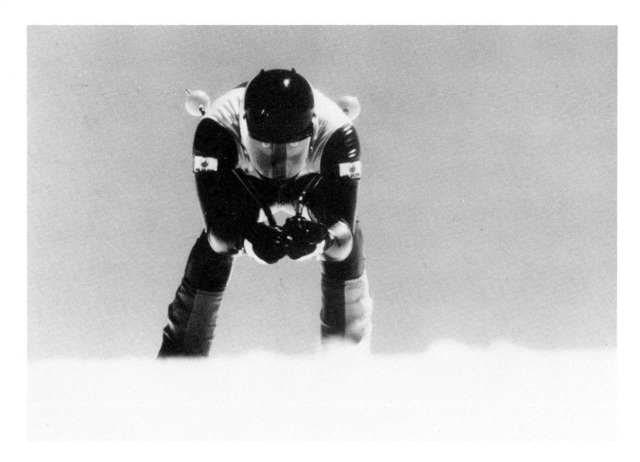

2 DON'T FIRE UNTIL YOU SEE THE WHITES OF THEIR EYES ...!

With the advent of faster telephoto lenses and faster, better quality colour film, today's photographer has many advantages over his predecessors. The ability to close in tight on the action in the middle of the field or court is clearly evident just by glancing at the hundreds of sports photos published weekly in magazines and newspapers. What is much rarer and consequently far more rewarding – when it works – is the type of shot where a photographer has focused in extremely tight on the action. This sort of picture concentrates attention totally upon the player or part of the player, with absolutely no surrounding distractions. It requires a steady hand or monopod and a sharp eye, a lot of imagination and a preparedness to waste a few shots to get the exceptional one – in other words, perspiration and inspiration. Powell's shot of Bjorn Borg serving at Wimbledon typifies this genre (*Fig. 3*).

In the five consecutive years during which he won the men's singles title and was undefeated, Borg was the subject of literally millions of photos. The majority of them are very repetitive because Borg is not an easy player to photograph. He has a habit of screwing up his rather close-set eyes at the precise moment his racket hits the ball. We have lost count of the number of Borg photos we have had to 'bin' because his eyes were closed. In addition, his footwork is extremely fast, so that he never appears to need to stretch for the ball, and stretching always makes a photo more dynamic. How best therefore to try to sum up this man and his remarkable achievements?

Powell's interpretation was to study the man and his face. He had been working at Wimbledon for several days and, watching Borg in the semi-final, had seen the shot he wanted. He moved in until he saw the whites of Borg's eyes. Fitting a 1.4 × teleconverter onto a 600mm f4 lens, he got into a position such that when Borg served

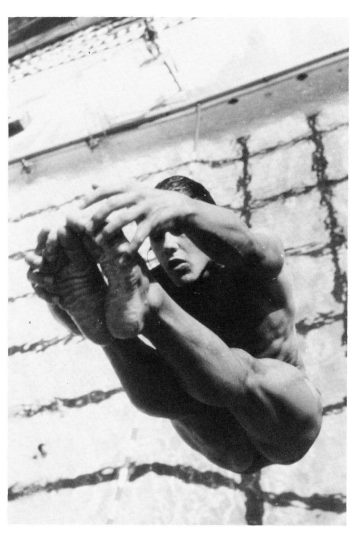

shot could have done. It can be argued that a conventional shot of Borg on either a 400mm or 600mm lens could have been cropped to produce a similar image. But this is the easy way out and unsatisfactory. Firstly, a picture editor would have to see the possibility of the photo and, secondly, it would only form a small part of the frame and consequently would not have the quality or definition necessary for enlargement.

Another *whites of their eyes* shot which has been on the All-Sport best sellers list is this picture of a skier (*Fig. 4*). It was taken at the brow of a hill prior to the 45-degree drop of the 'flying kilometre' (Kilometre Lanciata) in Switzerland. The event was a world record attempt to break the speed skiing mark of 198 kilometres per hour – and that's fast! Skiers were clad in aerodynamic, plastic, skin-tight suits, and specially adapted skis. The competitors began their descent near the Matterhorn. By the time this man had his picture taken, he was travelling well over 160 kilometres an hour and had his first glimpse of the sheer drop below him. Just look at those eyes!

3 SHOOT FROM ABOVE – OR BELOW

If, as we suggest, the art of creating the dramatically unusual sports photo lies in the preparedness to break the rules, then one of the golden rules must be to get above or below the subject. Changing the basic viewpoint in this manner gets away from the norm. In so doing it immediately sets the context of the picture in a way not normally seen by the eye. It transforms a mundane scene into a visually exciting, potentially breathtaking photograph. This isn't always possible during competition and the shot may have to be set up – but it is just as valid a statement because the photographer is trying to capture an intrinsic element of that sport.

The picture of high diver Chris Snode was, of course, contrived (*Fig. 5*). Photographers are certainly not allowed on diving boards – least of all with a step ladder! Nor would swimmers have been allowed in the pool below, but they were deliberately retained to show the height of the diving board, giving further impact to the shot.

5 *High diver Chris Snode caught in mid-air. Pictures like this can only be taken in training conditions. The swimmers in the pool below serve to emphasise the diver's height. The unusual angle is essential, as it juxtaposes Snode with the water, completing the picture.*

from a certain spot the Wimbledon sign, out of focus behind his head, gave a halo effect. Borg's eyes were open as the ball was thrown up to serve, and Powell was able to judge the shot at the moment when the ball left Borg's hand. It wasn't until halfway through the second set that he got exactly the shot he wanted. The result is the definitive Borg shot. It reveals more about Borg than any traditional action

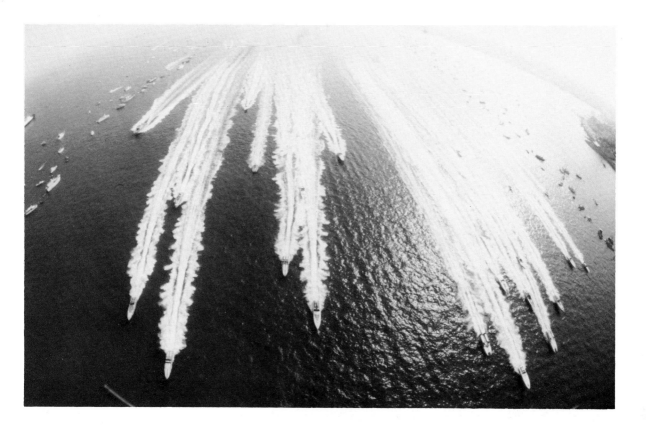

6 *Seeking out an unusual angle is one thing, but this picture derives further impact from being taken with an extreme wide angle lens (16mm). The earth's curvature is evident and the channels created by the powerboats emphasise their power.*

On one occasion it *was* possible to photograph from above at a sports event: the Cowes-Torquay-Cowes offshore power-boat race (*Fig. 6*). For this assignment, essential equipment was a helicopter and 16mm lens. The pilot was persuaded to fly very low over the starters as they streaked away in perfect echelon. The slight curvature of the horizon, caused by the ultra-wide lens, gives it an added dimension.

By contrast, low angles accentuate the drama of sport. Players leaping for the ball make a powerful picture if the photographer is standing or, better still, kneeling. If the camera is at grass level the players will appear to be almost in the sky and an added vitality is provided. Why not go one better? When a camera can be placed un-derneath the competitor, this effect is magnified further. This shot of American gymnast Shari Smith was, of course, set up (*Fig. 7*). By taking the girl outdoors, the beauty of a clear sky has avoided the more common gymnasium backdrop of rafter, curtains and girders – none of which is particularly photogenic. Duffy was able to outfit the gymnast in a red leotard to set off against the blue sky. Notwithstanding these facts, the unusual perspective taken from underneath the beam and the evident enjoyment and ease with which the girl is performing her handstand give the picture a validity that perhaps it did not deserve.

Another angle which can yield rewards occurs in show-jumping when a remote camera is placed between the two fences of one jump. The rider can be outlined against the sky and again a sense of drama and dynamism is added. With these low viewpoint shots, don't forget that cameras with automatic metering systems will be strongly influenced by the vast amounts of sky. Overriding the meter and giving extra exposure will maintain subject detail; otherwise the subject will be silhouett –

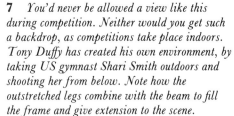

7 *You'd never be allowed a view like this during competition. Neither would you get such a backdrop, as competitions take place indoors. Tony Duffy has created his own environment, by taking US gymnast Shari Smith outdoors and shooting her from below. Note how the outstretched legs combine with the beam to fill the frame and give extension to the scene.*

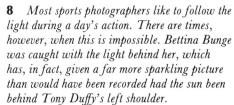

8 *Most sports photographers like to follow the light during a day's action. There are times, however, when this is impossible. Bettina Bunge was caught with the light behind her, which has, in fact, given a far more sparkling picture than would have been recorded had the sun been behind Tony Duffy's left shoulder.*

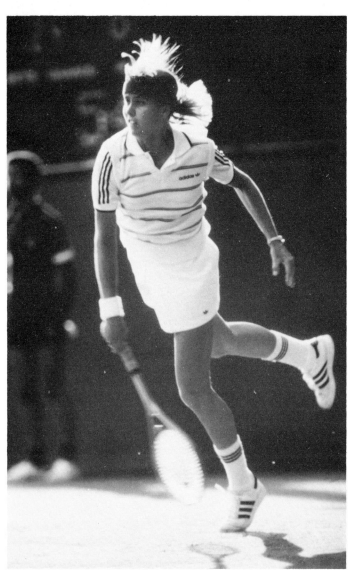

both techniques can give equally vivid results.

4 SHOOT INTO THE LIGHT

Almost the first lesson the amateur photographer learns is to shoot with the sun behind him. It's easy to see why. It gives greater depth of field and sharpness because of the narrower aperture and it is also easier to focus with the light behind the shoulder. It doesn't stop there – exposure problems and flare also become apparent when shooting towards the sun.

There are times, however, when, either through chance or design, the photographer must be prepared to shoot into the light. And the results can be very worthwhile; if the subject happens to be blonde, so much the better. The photograph of German tennis star Bettina Bunge (*Fig. 8*) gains from being taken against a setting sun at Wimbledon. The blonde hair is given a halo effect and the back lighting outlines and emphasises the player's serving shape.

When the sun gets low, we have found that on Kodachrome 64 film it is necessary to open up two complete stops to retain shadow detail. On Ektachrome 64, surprisingly, one and a half stops proves sufficient. A similar effect can be achieved when the sun is overhead, but the best results are definitely when the sun is low in the sky. A useful point to remember is to clean the lens and filters and make sure

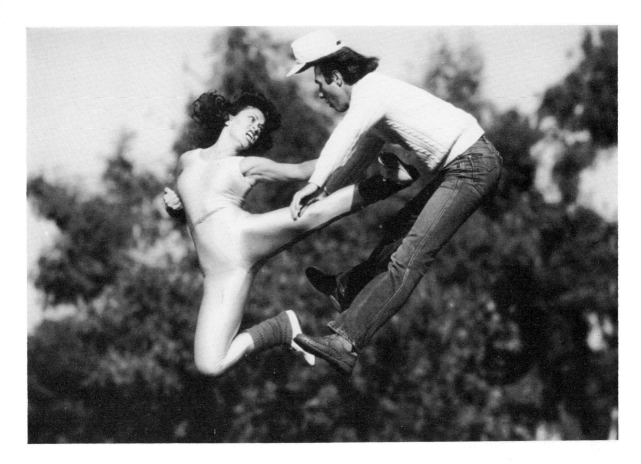

your lens hood is fully extended to eliminate extraneous flare. Motes of dust can ruin the photo when caught in the sun's rays.

5 BE PREPARED TO CHEAT A BIT

'A camera never lies' is an adage that has been disproved so often that the photographer can use the saying 'what the eye doesn't see' to greater effect. There is no rule stating that the camera must record the whole of a scene or that it cannot distort the truth – especially when it serves a purpose.

At sports events, the photographer is limited to what he can frame up in his viewfinder – whether it's a 6mm fisheye or 1000mm super telephoto. But he can go beyond this when creating his own picture. Typical of this approach is Tony Duffy's portrayal of American kata expert Karen Shepherd (*Fig. 9*). Kata is a variation of karate, and Karen is a back belt. Duffy wanted to catch the nature of the sport; the concentration of the power and force

9 *All's fair in love, war and karate. Karen Shepherd executes a well-aimed kick for the camera.*

it encompasses. To do so, he chose a flying kick pose. To emphasise it, he shot from very low on the ground and used a background of trees to show height. Of course it's a set-up picture, and one that the photographer gets the subjects to repeat time and time again until he feels satisfied that he has the best shot. The man's cap was already tilted to ensure that it would fall off. The picture shows a piece of stylised action – the event being shown *didn't actually happen*. In this respect the still camera picture scores over the moving image where some sort of contact would have to be made for effect. Here, the idea comes across that the man has been kicked, which gives the picture impact.

A simpler approach was adopted in the picture of the speed skier. It was taken during attempts on the world speed skiing record. On arrival at the course, the Kil-

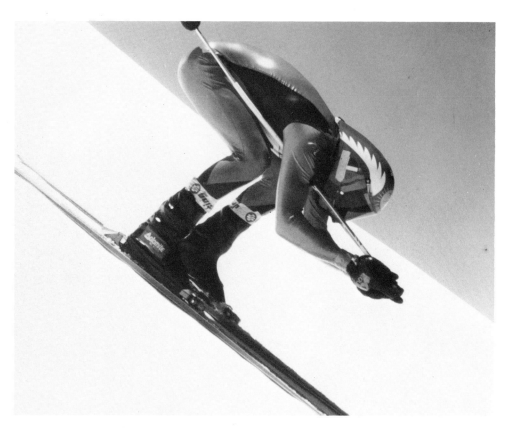

ometre Lanciata, Duffy had found it to be a north-facing slope, unsuitable for colour photography. He moved further up the hillside to a sunnier position, where the skiers were approaching (but not actually on) the main run. This is where he took the photo, before the steep, 45-degree drop. To illustrate the sport and atmosphere in good light he exaggerated the angle of the slope by simply tilting the camera.

10 *By tilting the camera angle slightly to increase the slope, Tony Duffy has used simple behind-the-scenes technique to make the picture more dramatic.*

11 (ABOVE RIGHT) *To get this very evocative picture, Steve Powell abseiled from the cliff top on a rope. He then had to climb back up again.*

6 WHO CARES ABOUT DEADLINES?

Some photographers feel that if they're not shooting reel after reel on their motor-drives they will be accused of not working. The safety in numbers philosophy is perfectly justifiable and indeed necessary, but there are occasions when it pays to visualise one picture and then work really hard to obtain it. On a practical level, this involves setting up for one particular shot with the right combination of light and lens. When on location, it requires a great deal of patience and a strong nerve as other dramatic photos unfold and are lost to your camera. Gambling in this manner involves risk as nothing is guaranteed, but when it works, it works well.

Powell's shot of Mats Wilander at the French Open Tennis Championships in 1982 (*Fig. 12*) is one such example of patience and reward. At that time, Wilander was a precocious 17-year-old hailed as the new Borg – and he became the youngest person ever to win the French Open. Like Borg, he was essentially a baseline player and very seldom came to the net. As some of his earlier matches had

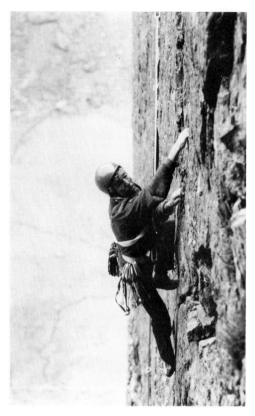

immediately make a beeline for the finish line or post has always amazed us. The start of an event is often the moment of maximum impact. The unleashing of all the pent-up energy as the athletes, horses and riders, swimmers, greyhounds or whatever hurl themselves forward into the fray.

Some technique and experience are required. For instance, at the start of an athletics sprint, the timing of the shot is crucial: let the starter's gun fire, count one and then shoot when the athletes are fully extended. Position is also critical: get forward at a slight angle to the start line and adopt a low posture as the faces will be looking downwards. The photo of the Ascot horse race start by Duffy (*Fig. 13*) has far more drama than a photo finish would have had – unless the photo finish involved the whole field of horses neck and neck. Likewise his photo of swimmers arching through the air (European Championships, Sweden, 1977) makes a statement that no shot could have made once they had hit the water (*colour plate 3*).

8 DON'T FIGHT THE LIGHT

More and more sports events take place at night time under floodlights for the benefit of television audiences and transatlantic scheduling. It makes the sports photographer's job that much harder. TV cameras are far more sensitive than still cameras and can obtain quite reasonable pictures way beyond the point where the stills man has washed his hands of the whole affair. There comes a time when it's just as well to stop fighting the light and bow to the inevitable. When that point of no return arises, the quality of the pictures will be so grainy and the definition so poor that one might as well go to the other extreme and start taking some impressionistic pictures at slow shutter speeds. Try $\frac{1}{4}$, $\frac{1}{8}$ or $\frac{1}{15}$ second and see what surrealist shapes and forms can be obtained. Have a go with a variety of lenses – further impact can be added by exploding a zoom at the same time as leaving the shutter open for a long time.

When the conditions are bad but the photographer feels that something can be salvaged from the shoot, he can utilise the available light. If it is harsh, use the shadows. Use the skyline to make silhouettes,

gone on for over three hours, Powell, by the time of the semi-final and final, had taken just about every sort of shot of Wilander on the base line and cast his eye around for a new perspective.

He arranged for permission to photograph from a television dug-out behind the base line at one end of the court at eye level. He then waited for the rare occasions when Wilander came to the net and volleyed. It was a long wait and as game after game unreeled from the base line, panic was not far from setting in. Eventually, however, his opponent played a short lob and Wilander, rushing in joyfully, was able to volley and put the ball away. Powell's photo of that lob was used as a double page opening spread in *Sports Illustrated*. The picture's strength lay in the rarity of seeing Wilander at the net. It was also odd to see him shouting for joy – or maybe it was surprise that he had actually come to the net (*Fig. 12*)!

7 START AT THE BEGINNING

There is an obsession with 'moments of victory' photos. Why sports photographers

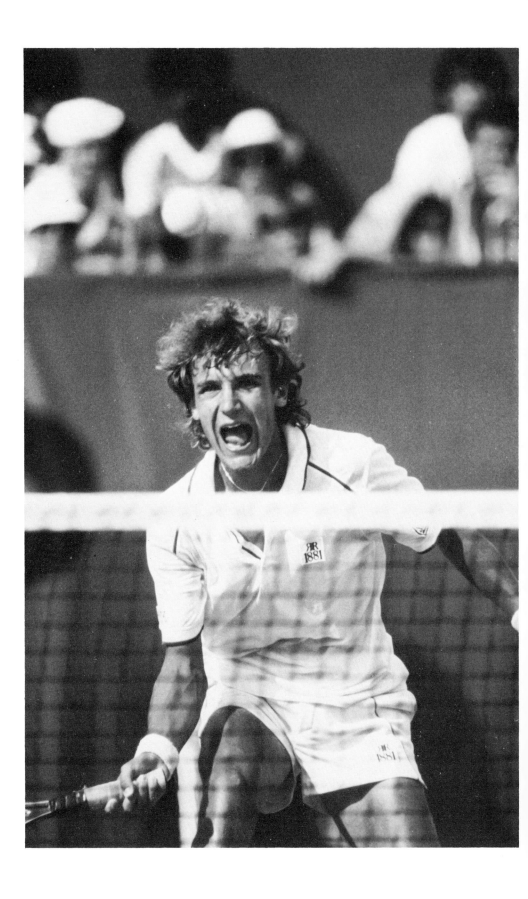

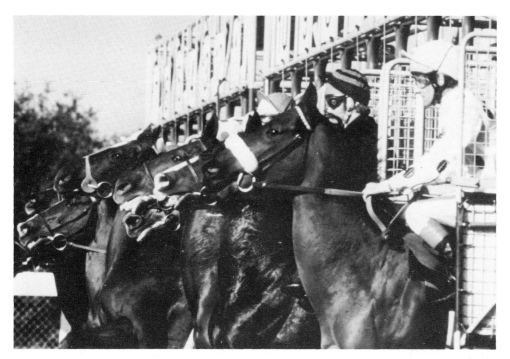

12 (OPPOSITE) *Mats Wilander pictured close to the net – a rare sight.* (Photo: Steve Powell.)

13 (TOP) *The start of races always presents good opportunities, so exploit them to the full. Tony Duffy's picture of the horse race, at Ascot, is replete with the horses' pent-up energy, which has been caught just as it explodes into action. The picture is all about power.*

14 (ABOVE) *When the light's fading and you're stuck half a mile away from the action, don't give up. Long range shots (which may or may not come off) are worth taking. Steve Powell took this picture of the Muhammed Ali-Larry Holmes fight at Las Vegas. Shots like these often find their way into general feature articles.*

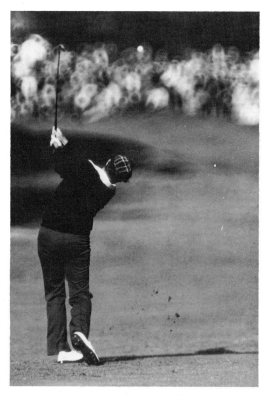

or deliberately go for golf ball grain. Even mediocre events can be transformed into a stunning shot. Using a ₃₀ second shutter speed, pan with the action. An overall dark background contrasted with the coloured patterns of athletics vests will make good material.

9 BACK TO FRONT

It is obviously important that the subject in a photo is recognisable and for this reason the vast majority of pictures are taken with the face showing. It's a safe formula but, by implication, the pictures are, therefore, somewhat repetitive. If, on the other hand, the photographer approaches from behind the subject, he is occasionally rewarded with a very exciting picture.

Just take a look at Powell's shot of golfer Ray Floyd, taken as the ball sings up the fairway (*Fig. 15*). Using a mirror lens, which adds to the impact, you can almost feel yourself on the course with the player. Another Powell picture was Ovett's moment of victory as he turned to face the Crystal Palace crowd and unintentionally gave the photographers a shot of his back. Most of them put down their cameras and yelled for Steve to turn round, but Powell took the shot, as it symbolised Ovett's rapport with the spectators.

An unusual football shot is, in a free kick situation, to take a photograph of a defensive wall with its back to the goal. If the ball gets through, the players may instinctively turn to the goal to see if the ball has hit the back of the net, giving the picture added emphasis. The All-Sport files include back shots of a boxer standing over his opponent, prostrate on the ground. They also have a shot of two fishermen walking across a hill away from the camera. This doesn't relate to a specific event, but helps create a generic shot of

15 *and* **16** *Ray Floyd driving up the fairway and Ovett waving in victory to the Crystal Palace crowd. There's no need for the face in these pictures, where the competitors are seen as an integral (but not total) part of their sporting environment. Both pictures, taken by Steve Powell, were shot with mirror lenses, creating the unusual out-of-focus donut effects.*

the sport. Pictures don't have to be taken from the front to make a statement.

10 BUILD YOUR OWN STADIUM

There are a whole host of marvellous sports pictures that can be taken in the studio. Indeed, this enclosed environment adds something to the shot by allowing the viewer to concentrate solely on the grace, beauty and line of the subject. Stadiums, tracks, crowds and other competitors are all eliminated. One top sportsman to visit the All-Sport studios was John Conteh, boxing's World Light Heavyweight Champion. This happy-go-lucky Muhammad Ali-type character was always a favourite of Fleet Street photographers and was usually pictured laughing and clowning around. He was surprised when we suggested to him that it might be interesting to show the *fear* in boxing. To add a touch of the classics we got Conteh to re-create the pose of the famous statue of a Roman boxer (*Fig. 17*). The photograph scored because it made a statement about this particular boxer which had not previously been made. It was possible only by taking the boxer into the photographer's own environment. It shows the sports photographer's ability to re-create what he sees in the stadium in a controlled way within the confines of a studio – and in the form in which he wants it portrayed.

11 DON'T TAKE THESE TEN AS GOSPEL

Ten commandments to break the rules. But they only offer an alternative approach and each photographer can seek out his own individual re-creation of sports scenes. The main point is not to be governed by standard procedures. Trying to capture the unexpected, or another, unusual essence of a sportsman is worth the extra trial and tribulation. The ten ideas here for breaking the rules are merely a beginning.

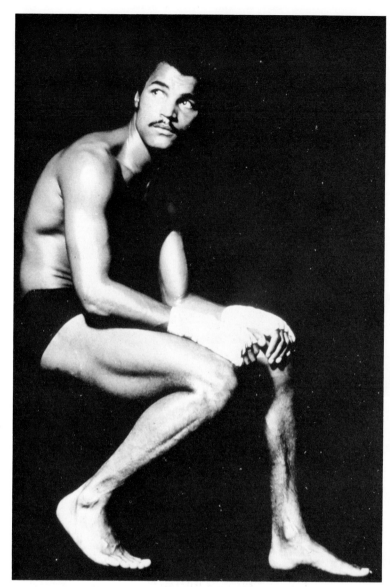

17 *John Conteh, extrovert boxer, presented in an unusual yet effective pose. By building your own stadium, you have total control over your sporting subjects, giving you the freedom to explore different modes of presentation.*

2 The Human Element

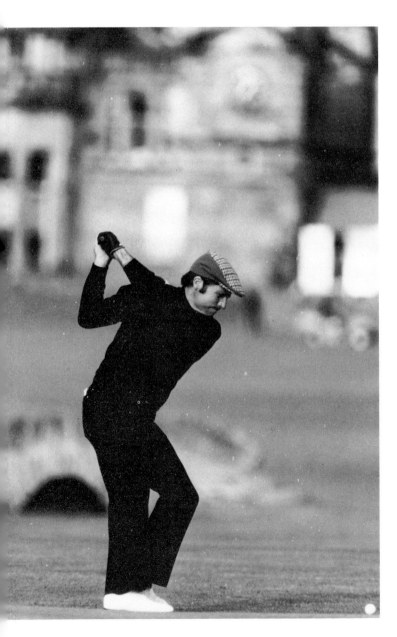

Tony Duffy's view is simple. The grass is always greener on the other side of the fence. There have been times when, wishing to do a feature with John McEnroe or to set up a photo session with Steve Ovett, he has envied landscape photographers whose subjects don't tell them to get lost or disappear in the opposite direction at sub-four-minute-mile pace. Even studio and location photographers working with professional models have an advantage – the models are being paid to be photographed and have a vested interest in helping the photographer get the best results.

Sports people, by contrast, are not only generally uninterested in the photographers or their problems, but often actively resent their presence. South African golfer Gary Player has become almost neurotic about photographers (whether amateur or professional) clicking their cameras just before he strikes the ball. It distracts him and causes those minute lapses of con-

18 *Every sportsperson has his or her own individual temperament, and the photographer must approach his subject accordingly. Gary Player is a golfer easily upset by intruding lenses. Here the problem is overcome in three ways. Firstly, the picture was shot during the practice round, to avoid upsetting Player during competition. Secondly, a long lens, a 600mm fitted with a 1.4 × teleconverter (making 840mm), was used. Finally, the photographer, Steve Powell, shot from behind the golfer. This has given a golfer's eye view of the eighteenth at St. Andrews – a view not normally seen in photographs. Despite the angle, the face can still be seen.*

centration which can lose him the game. Golfing photographers jokingly quip that Player can hear the click and whirr of a camera 50 metres away. On one occasion, Duffy was stationed at least that distance for a head-on shot of a drive. Player placed the ball on the tee, glanced up and noticed the long lens pointing at him. He then glared for several long seconds right at the lens, making his presence felt. Woe betide any photographer who takes a picture at moments like that.

In dealing with sport it is important to remember that we are dealing with people. Even in equestrian and motor sports it is people who ride the horses and drive the machines. In many cases they are extremely young and even though they might be Olympic champion swimmers or gymnasts, they may still be only 12 or 13 years old. This fact is very easy to forget in the presence of someone like Nadia Comaneci who scored perfect tens and won numerous gold medals in the 1976 Olympics. In the hustle to get pictures and quotes from her, the media forgot that she was in every respect other than gymnastics a shy, awkward, rather immature girl. One journalist asked her why she was in tears on her triumphant return to Bucharest after the Olympics. 'In the crush of people the head of my favourite doll got torn off' was the shattering reply.

So what are the ground rules for dealing with sports stars or would-be sports stars?

BE SENSITIVE TO THE SITUATION

Even when sports stars are out of their teens they are, in the majority of cases, under 30 years old and have led a very specialised existence. This tends to make them experts in one subject and rather unworldly in other respects. Never forget that they are human beings under the most extreme stress imaginable. The Olympic Games or World Championships are the ultimate test of character.

At the grass roots level, a one-to-one race or competition with a friend or family can set the adrenalin going. The presence of a few spectators can trigger off butterflies in the stomach. Imagine, then, competing in the Olympic Games in front of 100,000 people with the world's media focusing its attention on you. It's small

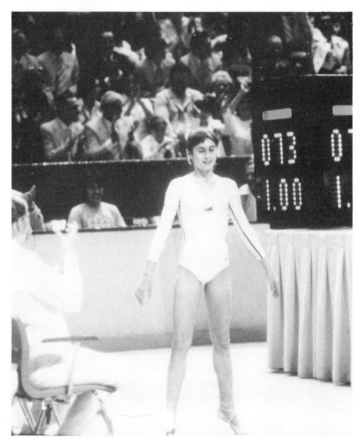

19 and **20** *Girl gymnasts seem to be younger and younger all the time. These two pictures of Rumanian star Nadia Comaneci illustrate the fact that Olympic stars are still human beings. When not performing in front of millions of TV viewers, Comaneci still has to attend classrooms – often overlooked by the world's press.*

wonder that the pressure of national expectation can be too much to bear. For many years Virginia Wade claimed that the only reason she didn't win Wimbledon was that the British public so desperately wanted her to do so. Sebastian Coe had the pressure of being expected to win the 800 and 1500 metres in the Moscow Olympics, and England's footballers faced a similar test of character in their World Cup games. A Yugoslavian world record holder at 800 metres, Vera Nikolic, attempted to commit suicide after the 1968 Olympics when she was surprisingly beaten out of the gold medal.

Books have been written by psychiatrists on the extreme pressures now facing top class sportsmen and women and there can be no doubt that these pressures are rising as money prizes increase, which in turn brings about higher standards and more competition. The photographer is often not dealing with a calm, rational person but rather with a high-spirited thoroughbred living on his nerve ends at the moment of his greatest stress and pressure.

THE KID-GLOVE TREATMENT
Bearing in mind the athlete's predicament it makes no sense to stick a camera lens under the nose of a defeated sportsman. Failure is a bitter pill to swallow and, even though it might be a news story, always use a long lens. To crowd him at that moment will only result in him running away or suggesting that the photographer does. In any event, the best pictures of losers are likely to occur if the subject isn't aware of the camera.

Even in victory an athlete can be unpredictable. After his world record-breaking victory over the favoured German, Hingsen, in the 1982 European Athletics Championships, Daley Thompson was trotting around on a lap of honour, having collected a Union Jack which he had draped round himself. Just then his main rival Hingsen made as if to come up and shake hands with him. Daley hadn't seen him and when we pointed him out, Daley snapped 'I am not going to share my moment of victory with him' (*Fig. 22*).

Some sportsmen are renowned as temperamental artists. Ilie Nastase and John McEnroe are two such examples. It is said

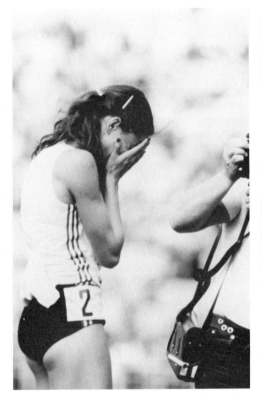

21 *While the headlines are about winners, sport also has its fair share of losers. Tony Duffy used a long lens for this poignant shot – but just look at that photographer barging in on the girl's distress.*

22 (OPPOSITE) *Daley Thompson enjoys his moment of glory shortly after winning the decathlon in the European Championships and breaking the world record at the same time. It was an occasion he didn't want to share with anyone else.*

that unless they get fired-up they do not produce their best tennis. When they do get the bit between their teeth, woe betide any photographer who happens to catch their eye or incur their wrath. It can be a sobering experience to have either of these two screaming at you in view of the centre court crowd and a nationwide TV audience.

CO-OPERATION
Some sportsmen have been photographed so many times by both still and cine photographers that they know more about what

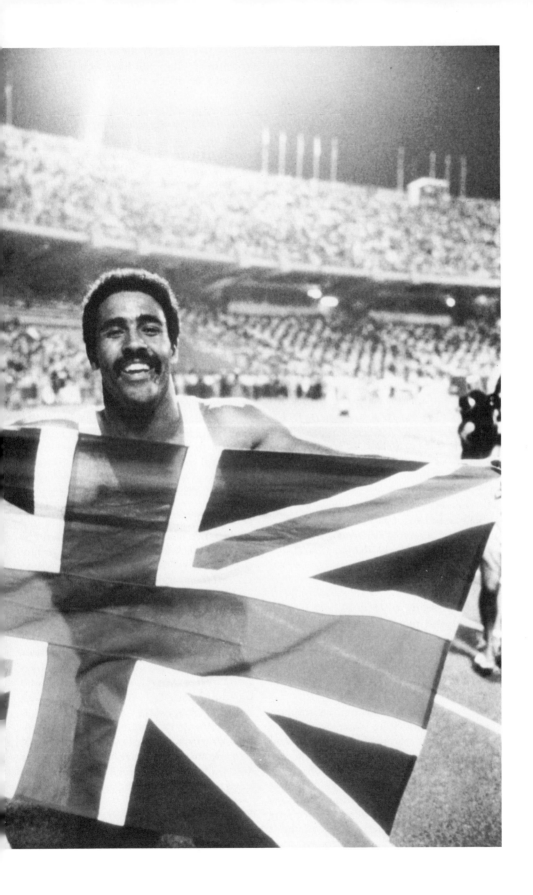

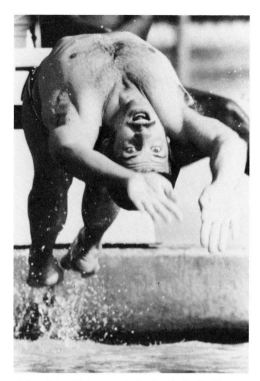

23 *John Naber caught in the air by Duffy. Having good relations with athletes is important: Naber was persuaded to repeat the start time and time again in order to get the best shot.*

24 (OPPOSITE) *John McEnroe winning Wimbledon in 1981. A player renowned for his temperament, pictures of him arguing with the umpire are nothing special. But this picture paints him in a different light, showing a rare outburst of joy.*

makes a good picture than the photographer might suppose. Never discount any suggestions put forward by a sportsman at a photo session – they are often based on personal experience of what works and what doesn't.

Some sportsmen are keen photographers themselves. Mark Spitz is one person who is just as happy talking about cameras and lenses as about swimming. If you are trying to photograph an athlete from an unusual angle take him into your confidence. Let him look through the lens to see what you are trying to achieve. In many cases he will be flattered by the camera's attention and what it can do for him.

There is a touch of the narcissist in many sportsmen. Once you have won their interest and co-operation you are home and dry.

Duffy once had to do a backstroke start shot of Olympic champion John Naber from an unusual angle. It was very much hit or miss and John proceeded to reel off no less than 20 or 30 flat-out starts until his back was red raw. He was most understanding in his attitude as the photos were needed for an advertising campaign just after he had turned professional.

When shooting women athletes, they would usually prefer that their hair wasn't messed up, their faces contorted with strain or their muscles standing out. Try and keep them looking as feminine as possible and let them know that you are interested in photographing them from the most flattering angle.

DO YOUR HOMEWORK

Brendan Foster relates the story of a photographer who had phoned him in very enthusiastic terms asking for a photo session. Explaining his commission to Brendan he said: 'I really want to get inside your skin on this feature. I want to spend a couple of weeks following you around all over the place.' A couple of minutes later he asked: 'Have you broken any world records lately?' As it happened Brendan had broken the world 3000 metres record the previous week and this faux-pas gave him the excuse to terminate the conversation ... and the photo request.

The more knowledge you have on the subject's sport and career the better. If you know very little about it don't try to pretend that you do. Be absolutely honest and straightforward and ask their help. The one thing they don't like are know-alls who pretend to be experts or who offer unsolicited and unwanted advice. When dealing with non-English-speaking sports stars, it is often difficult to establish any sort of rapport. In these circumstances it is advisable to take along a picture of an angle that you want and any previous pictures you have taken of them.

SAY 'THANK YOU'

Virtually every sportsman or sportswoman who has been photographed either asks or

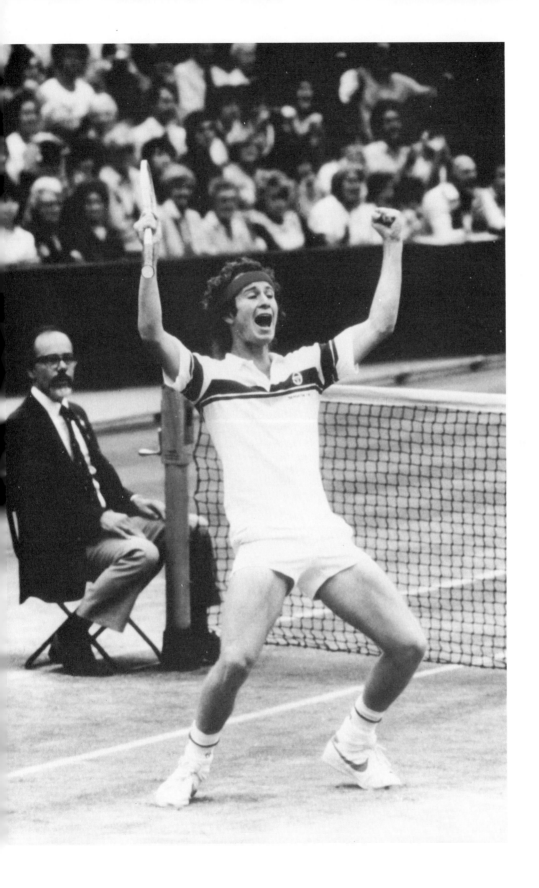

hints to the photographer that they would appreciate a few prints. It is amazing how few photographers ever respond to this request which, after all, is very reasonable. The athletes have given up their time and unless they are being paid for it a photographer is under a moral obligation to help them in some respect in return. This is especially true when it is considered how much training time might be missed by embarking on a photo session. The All-Sport philosophy is always to send either pictures or transparencies, following these up with cuttings and articles where the photos have been used. The number of times sports stars have thanked us for this courtesy convinces us that it is the exception rather than the rule. Incidently, it also promotes business in a roundabout sort of way as the sportsmen tend to recommend photographers they like to clients and other people requesting pictures.

There is also the fact that if the athlete has helped and has been given a set of pictures from the shoot, he is much more likely to be co-operative for future sessions. If the athlete is world class, he will be the subject of repeated requests from the world's media. It's a tremendous asset if it's your name that stands out as a good

25 *Will tomorrow's photographers have to pay for the right to photograph the stars? Money is already creeping in, partly due to the intense competition between photographers to get the best shots. Just look at the number of pros lined up to take pictures of Sebastian Coe just putting on his spikes.*

26 *In trying to capture the human element, always be on the look-out for off-beat shots that say a lot about the athlete. Tony Duffy took this shot of a thoughtful Chris Lloyd at the Wimbledon players' dressing room – the type of picture you'd never find on court.*

photographer among a list of 20 or so anonymous practitioners.

PAYMENT FOR PHOTO SESSIONS

Increasingly nowadays the photographer hears the request from an athlete: 'How much do I get paid for this?' This even comes from sportsmen in Olympic sports who are supposed to be true-blue amateurs.

There are two ways of looking at this. From the sportsman's point of view they

argue that the photographer (and everybody else) is making money out of them and it's only reasonable to assume they should have a bite of the cherry. The photographer might argue that until a picture is sold (and there is no guarantee of this) no money will be made, and in any case they are risking wasting their time and expense in photographing the subject. Furthermore the publicity that the photos produce can only benefit the subject in making him more of an attractive proposition to promoters and sponsors. Many sports stars nowadays have agents and business managers who handle all this sort of detail for them. Some of them take the broad view that publicity furthers their charge's career and others hold out for every last cent.

Sometimes the payment of money to athletes can lead to a spiralling effect as newspapers vie with each other to secure exclusive contracts. They effectively price athletes out of the ordinary market-place. Most world superstars of sport now come into a category where, no matter what the credentials of the average photographer or his organisation, it is very difficult to obtain a photo session without a commercial agreement.

We rather like the attitude taken by the top American sports magazine, *Sports Illustrated*. They flatly refuse to pay a cent for the privilege of photographing someone for their magazine. On the other hand they will go to inordinate lengths to recompense the subject in other ways. Lavish dinners and hospitality, flowers to wives and girlfriends, tickets to shows and large colour blow-ups from the photo sessions. It is up to each photographer to work out his own views on this question, but whereas in show business the stars usually welcome attention as good publicity, sports stars are tending to become more prima-donnaish in their attitude towards the media.

CATCH 'EM YOUNG

Once sports stars have arrived on the international scene, it is very difficult to establish a good working relationship or friendship with them. When they are on their way up, however, they welcome any interest. If you can spot the outstanding talent – which will rise to the surface like cream in a bottle – then you are well on the way to a future working relationship with that individual.

Sometimes you can get too close to them and, as you are friendly, you hesitate to ask them for photo sessions and favours that somebody slightly more distant will have no hesitation in requesting. But, by and large, there can be no doubt that if they have known you on their way up they will not suddenly turn their backs on you when they have arrived. The sports agency play its hunch in talent-spotting very much like a theatrical agent.

CONCLUSIONS

Whether the sports people deserve it or not, the photographer must handle them with kid gloves. Being too intrusive is counter-productive and, as it is the photographer's job not just to *take* shots but also to *make* them, he is his own worst enemy if, through bad judgement, personal ambition or mere thoughtlessness, he loses potential money-spinning shoots.

Most of the points made in this chapter should be obvious, but it's easy to be forgetful. The photographer should never approach an athlete immediately before an event, when he is psyched up and all his mental processes are attuned to victory.

Training can provide a useful basis for feature work. This allows the athlete to continue his normal training pattern and, to an extent, forget about the camera. The photographer can then work on the various training methods. If one shot requires special attention, there shouldn't be a problem in the athlete repeating a portion of his training pattern for the camera.

Different athletes require handling in different ways: a temperamental tennis player, an immature gymnast or an extrovert footballer – the photographer must handle them all. And don't forget that within a sport, even within a single team, there are different types of people, from the egocentric comedian to the team's quiet man. And they're all potential subject matter for the photographer.

3 To Record or to Create?

What is the sports photographer's primary role? Is it to record or to create? Is it sufficient to capture accurately the moment of drama, the winning goal or the knock-out punch? Or should the photographer endeavour by means of photographic technique, or even distortion, to convey a new and original image of the action which is taking place before him?

THE CONDITIONS OF THE ASSIGNMENT

All too frequently the Fleet Street photographers have become the whipping boys in this perennial argument. Freelance, agency and other sports photographers are apt to assume delusions of grandeur when dismissing Fleet Street sports photographers' primary interest as the 'flash point picture' – whether it's the goal, the sending off, the miler crossing the line. They are conveniently forgetting one very important point – the requirements of the job impose conditions which restrict freedom of choice as to whether to record or create shots, whether to take or make them.

Daily newspapers

Take the Fleet Street newspapers. The daily paper picture editors require their sports photographers *not* to miss the important picture. It doesn't matter what other great pictures the photographer brings back – if the winning goal or the star player being sent off is not amongst them then he will not last long in his job. This criterion probably dates back to the pre-television era when people would buy the morning papers the day after an event, purely to see a photograph of an incident which they had possibly heard described on the radio. It is debatable whether the philosophy still holds good today when the incident can be run and re-run countless times on TV, video replays, in slow motion and from different angles. Indeed there is a growing tendency to look for the unusual shot in these replays.

The weeklies

The quality Sunday papers (especially *The Sunday Times* and the *Observer*) have always been a different category to the daily papers. Being produced only once a week they are able to look at a sports story in a lot more depth. Very often this story is completed early in the week and the photographer assigned to do the job has to take a photo capable of lasting a few days until publication. It is no coincidence that photographers like Chris Smith of *The Sunday Times* and Eamon McCabe of the *Observer* have earned reputations as very creative photographers over the years, as they are constantly required to make sports pictures and to think about a new angle, a new perspective or a new technique. Their colleagues on the daily papers don't have this luxury – or this problem, depending on your point of view.

Newspaper photographers are not the only sports photographers who have disciplines imposed upon them which restrict their choice of whether to record or to create. There cannot be many – if any – photographers who can just attend a sports event with a view to enjoying themselves and taking whatever photographs appeal to them without any thought or concern

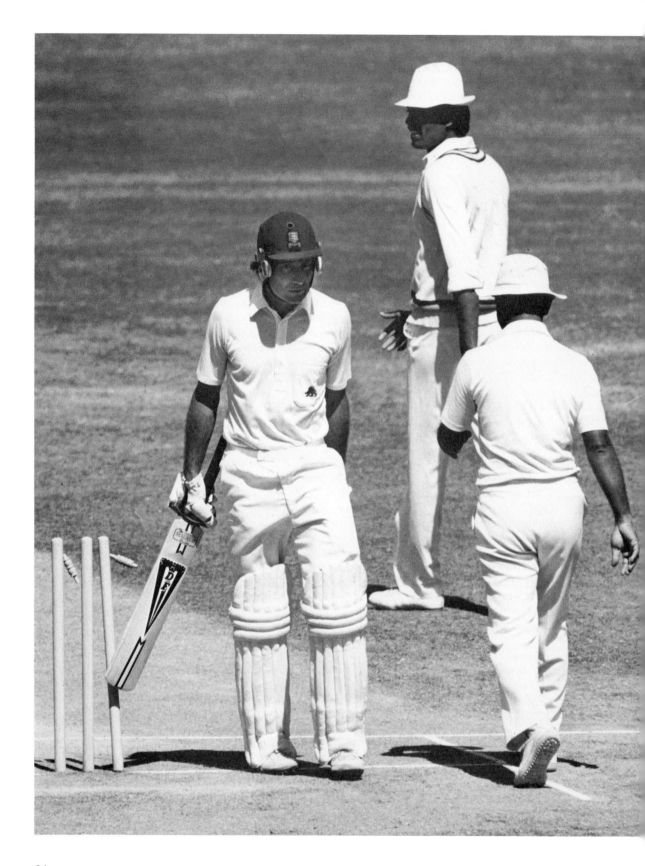

27 and 28 *Two photographs from the MCC's tour of India 1981–2, that amplify the record or create issue.*
27 *Keith Fletcher creates a controversial issue by hitting his stumps in frustration after being given out. This caused a sensation and was published in the* Daily Express. *In the long run, it was a major contributing factor in Fletcher losing the England captaincy.*

28 (ABOVE) *One of the issues of the tour was the standard of umpiring. This off-beat shot of Indian umpire Swarup, during the first Test match of the tour, highlighted the arguments and was published in* The Observer. *These pictures demonstrate the differing requirements of daily and weekly newspapers.*

for covering their expenses and making a living from those pictures. Whether the non-newspaper photographers are working as freelance, agency or photographic library photographers, or are on commission from certain magazines, television companies, sponsors or promoters, they will *all* have specific requirements.

Library/freelance photographers
Most of the library/freelance photographers have to take a high proportion of file photos suitable for editorial purposes such as magazine covers and 'inside' photos showing good, sharp stock action of the main stars in that particular sport. It's helpful to get as many of the other contenders as it is feasible to take (they may be tomorrow's stars). There is a wide variety of magazines who will be interested in largely similar shots of a star. Not just the specialist sports magazines, but also news- and feature-orientated journals. And don't forget the specialist photographic magazines, who are always interested in photos that highlight a certain technique.

The photographer may additionally be required to shoot some advertising-type photos where the player is not readily identifiable and the picture can therefore be used for advertising without incurring problems with the player's agent (or governing body if he is an amateur sportsman). He may be briefed to photograph the referee and the linesmen at a football match and possibly to take a photo of the outside of the ground showing the football club sign above the main entrance. He may be told to photograph the fans of both sides and the mascot. During the game he will be trying to get the stock photos but, at the same time, obtain one or two good action sequences which are saleable as a sequence; perhaps a good shot of a foul tackle and the ensuing defensive wall line-up; perhaps some good close-ups of the goalkeeper and the team manager or trainer in the dug-out at the halfway line. With all these requirements running through his mind he may be forgiven for thinking that the necessity to create a masterpiece can simply be left until the following week.

Commissioning agents
The commissioning agent whether it be a magazine, publisher, promoter or sponsor can be even more restrictive. A magazine may be doing a feature on just one player in a team, and may require the photographer to concentrate on this player even when the action is in a different part of the field. The sponsor may insist that all photos show some identification of the sponsor's logo, whether it be a banner at the side of a track or a number on an athlete's vest.

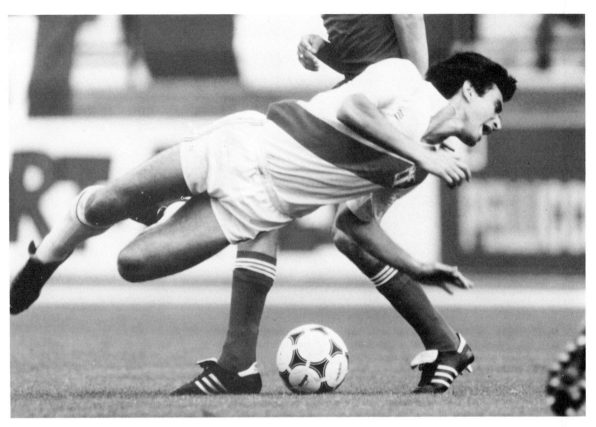

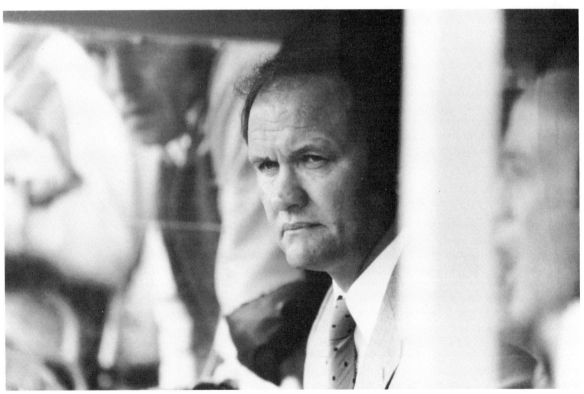

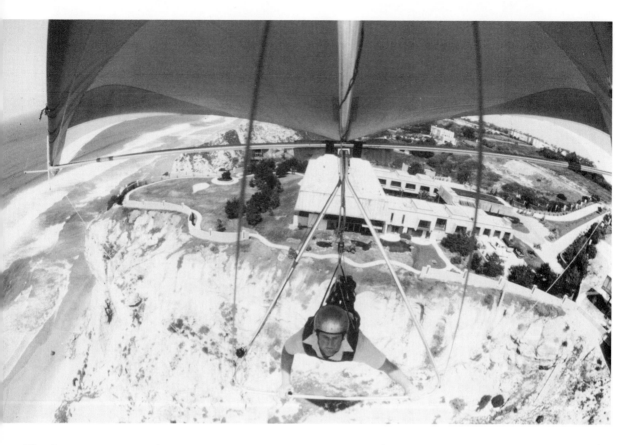

29 (OPPOSITE, ABOVE) *Closing in on the action. Peru's Oblitas is unceremoniously upended during a World Cup match. A minor incident, but a telling photograph.*

30 (OPPOSITE) *The photographer might be required to turn his lens away from the action. Ron Atkinson, Manchester United's flambuoyant manager, was caught by Dave Cannon with a worried look on his face.*

SELF-IMPOSED RESTRICTIONS

Apart from the restrictions imposed by the requirements of the job there is one other restriction, which is self-imposed. That is the photographic philosophy of each individual photographer. Like painters, poets and composers, each photographer has his own personal style. He is very often unaware of what this is himself, and is quite surprised when people recognise his photograph in a magazine. As regards the controversy of whether the prime role is to record or to create, the photographer himself very often unwittingly supplies the answer.

31 (ABOVE) *Steve Powell's picture of the hang-glider, taken by remote control with a wide angle lens.*

The 'record' philosophy

There are two basic schools of thought. One of them is that sport is so exciting, dramatic and visual that the photographer's job is merely to record what is taking place before his eyes and to freeze that moment in sharp focus. Very often when this is done, factors which were invisible to the naked eye become dramatically clear. The beauty and balance, drama and commitment of sport are then a cause for wonder and comment. A good example of this philosophy is Duffy's photo, of the 15-year-old synchro girl which won the International Sports Photo award in 1982 (*colour plate 1*). There was no photographic trickery or creativity used in this picture; it was a simple, straightforward, action shot. The commentators have enthused over the fluidity, grace, youth and vitality of the picture, *but these are totally in the hands*

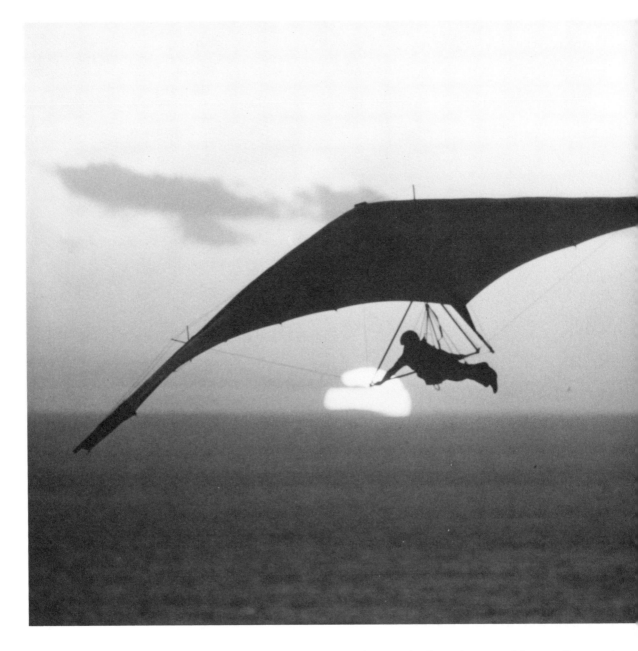

of the girl. All Duffy did was compose and focus and press the shutter at the right time with the right technical sequence to give a clear, sharp image. He did visualise the shot, but only in the sense that he recognised the beauty of what his eyes were seeing.

The 'create' philosophy

On the other hand, there is an equally valid school of thought amongst sports photographers which claims that photo-graphy is such an exciting medium and capable of so many variations and visual effects that the sports photographer ought to explore the potential to change, distort or add a new perspective to the sport. These photographers, one of whom is Steve Powell, attempt to add an extra ingredient to the action. A good example of this is Powell's photo of the hang glider over California (*Fig. 31*). Taken by remote control camera and with a wide angle lens fixed to the strut of the machine, not only

not claim that his work is pure art. That is not to say that sports photography cannot be art. Take this shot of 5000 metre runners from overhead during the World Cup in Montreal (*colour plate 7*). This photo, simply entitled 'Shadows', can be viewed on two different levels. As a vertical picture it shows the best 5000 metre runners from the five continents competing in a race. On the level of art, if the photograph is viewed horizontally the shadows cast by the runners accurately reflect the figures depicted on the Grecian vases of 2000 years B.C. – produced in the days of the ancient Olympics.

Whilst this sort of photograph is very pleasing when it happens, there is no doubt that a sports photographer would soon starve if he relied entirely on these photos for his bread and butter. As in all things the probable truth of the controversy between recording and creating lies midway between the two.

32 *In this shot, a 600mm lens was used for the shot of the hang-glider against the sunset. The final effect is one of simplicity. The picture took a lot of persuasion. Winds and sunsets do not go together, putting the hang-glider at some risk. He was eventually persuaded to launch himself off a tall cliff into a zero wind. The deal was that if he couldn't land back on the cliff but had to land at the bottom, the photographer would help him carry the hang-glider back up the hill. He didn't land on the cliff, so Powell had to keep his word.*

can the participant and his kite be clearly seen, but the photo also conveys the danger and excitement that the participant must feel whilst, at the same time, making the viewer gasp at the sheer spectacle of it.

The proponents of the 'create' school of thought are more apt to claim artistic qualities for their work. In most other branches of photography, artistry is a common claim, and it is perhaps a measure of the sports photographer's essential common sense and practicality that he does

4 Take One Athlete

Competition is my life – winning is my only goal. Everything I do is directed toward that end and I will never permit anything to jeopardize it. Not personally or publicly.

Daley Thompson in *Daley Thompson: The Subject is Winning*, by Skip Rozin (Stanley Paul).

Now try taking pictures.

THE SUPERSTAR IMAGE

Today, with the world's top sportsmen and women reaching superstar status, many areas of the publishing world regularly require features on them in major spreads. Each magazine or book will want to depict that star in its own house style or perhaps try for a story that is a little unusual or imaginative. One such superstar is Daley Thompson, European, Commonwealth and Olympic gold medallist. Add to that a world record and you've got the world's premier athlete. That's because he's won all these titles in the most gruelling test of man's athletic fitness – the decathlon. He has been heralded as the world's greatest all-round athlete and, as such, is of immense interest to the whole publishing market.

On the basic level, pictures of Daley feature him in one of his sporting roles. Now that's not as simple as it sounds, because the photographer has a choice of ten events: 100 metres, long jump, shot putt, high jump, 400 metres, 110 metres hurdles, discus, pole vault, javelin and 1500 metres.

To give a magazine picture editor the best choice, the photographer has got to record all ten events – which means following the decathlon for a period of two days. By the end of the second day, when athletes and photographers are at their most tired, the best shots can often be gained, simply because that's the moment of victory. By

33–42 *Two days in the life of a decathlete: Daley Thompson captured in each of the ten disciplines (shot by Tony Duffy at various events).*
33 *Leading the opposition in the 100 metres.*

34 (FAR LEFT) *High in the air in the long jump.*

35 *At full stretch putting the shot.*

36 (FAR LEFT)
Clearing the high jump.

37 *Pounding round 400 metres.*

45

this time it's usually dark, so the photographer, who has been following the event throughout in daylight hours, must now be prepared for the evening floodlights.

Day or night, flexibility is the key. Dynamic shots of Thompson participating in any of these ten events will be published in the specialist athletics publications, such as *Athletics Weekly* or *Track and Field News*. They'll also be snapped up by more general sports magazines – *Sports Illustrated* is a typical example.

For these magazines, the creative photographer can get ahead of the field by being aware of the likeliest stars of the future. Indeed, good sports photography helps to develop the superstar image. Following a tried system of trying to spot new talent early, Tony Duffy first met Daley in the mid 'seventies when he was a good club athlete, long before he started showing his full potential as a world beater. After many photo sessions at club level Duffy went on to record his first major win at the Edmonton Commonwealth games in 1978, getting pictures of him in each of his ten disciplines.

38 *Getting down low over the 110 metres hurdles.*

39 (OPPOSITE) *Preparing to unleash the discus.*

Daley's cocky sense of humour combined with his athletic skill take him away from the enclosed world of the athletics stadium. Editors of children's comics want Daley pictures because he's a hero; the news magazines require shots because his outstanding success creates news; women's magazines are interested in the private Daley away from the sport; sportswear companies want a striking and instantly recognisable figure to model the latest clothes; colour supplements are always on the look-out for unusual and offbeat features to fill their pages; and so it goes on. There's hardly an area in general publishing that hasn't featured him in one way or another.

Each feature requires pictures and, as often as not, they've got to be away from the track. One shot taken by All-Sport featured Daley standing above all the implements used in the decathlon (*Fig. 43*).

It's a very posed picture, but it is simple and effective, conveying to the magazine concerned – and its readers – the master in control of his sport with the tools of his trade at his feet.

Getting to know the man

As time went by Daley became well-used to Powell's and Duffy's lenses thrusting at him both in competition and in relaxed mood. Close friendships were forming, allowing the photographers greater opportunity to picture him both on and off the track. Prior to the Moscow Olympics in 1980, Powell flew out to San Diego to photograph him at his winter training camp, well away from the cold English winter.

Working primarily to build up the All-Sport files, Powell spent ten days taking general off-beat pictures of Daley in workouts with his partners Richard Slaney (discus thrower) and Pan Zeniou (Greek decathlete). Throughout the winter months, Daley practises constantly at all his events, and pictures of them together with him relaxing around the university campus, featured prominently. Powell was trying to get an insight into the man and his relationship with others. But what emerged as the primary element in all this was the loneliness of the training; the constant slog of working through all the events, day in, day out. The strongest picture to emerge was a recognisable silhouette of Daley running along a beach which conveys this sense of loneliness.

While the commercial benefits of a photographer spending ten days in San Diego may not be immediately apparent, these off-beat training shots are always in demand as good 'behind the scenes' pictures. But with someone like Daley, who will continue to figure in major sports events for some time, it's a definite advantage to get to know him, put ideas together and set up potential features in the future. And that's exactly what happened.

40 (OPPOSITE) *Approaching the pole vault.*

41 (THIS PAGE) *Throwing the javelin.*

42 *Competing in the decathlon's concluding event, the 1500 metres.*

43 (FAR RIGHT) *Establishing an early rapport with an athlete is important. Tony Duffy took this picture of Daley in 1978, when he was a precocious 18-year old. All the implements are there, with the javelin and pole leading into the bottom centre to give depth to the shot. Track events do not have 'implements' so, to picture them, the starting blocks are shown and, for the 1500 metres, the 'three laps to go' sign. Notice the backdrop: the electronic scoreboard at the Crystal Palace track.*

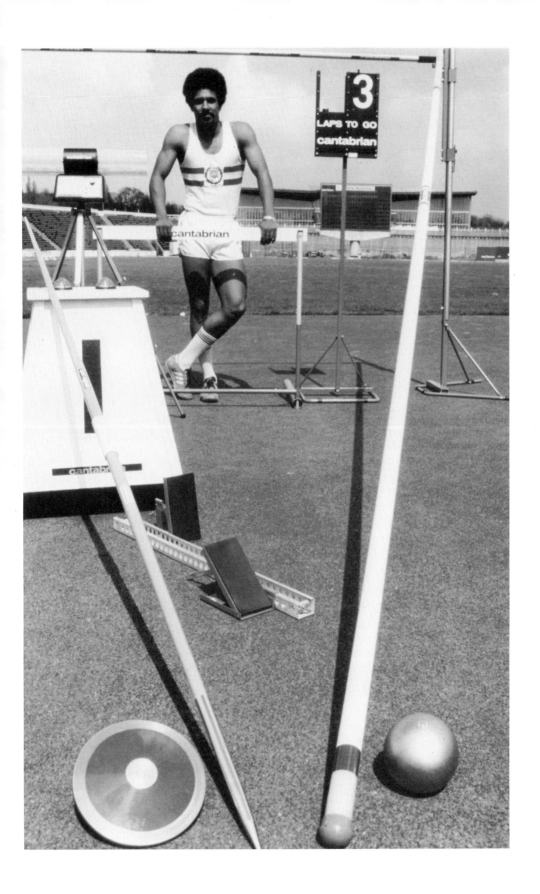

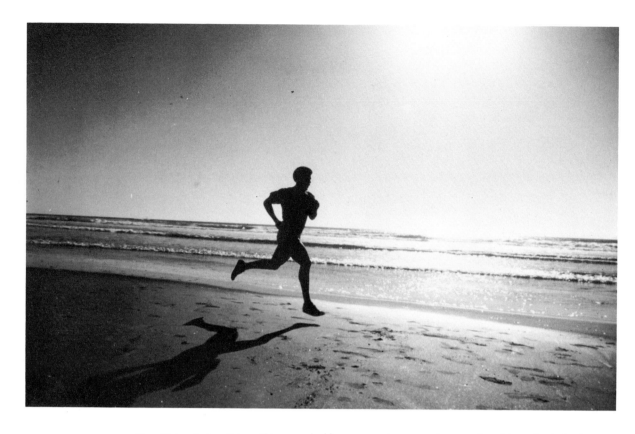

44 *Taken in San Diego, this recognisable silhouette of Daley training along the beach was taken by Steve Powell after he had spent a considerable time with Daley at his winter training camp.*

TAKING A DIVE

From various conversations between photographer and athlete, it came about that Daley was interested in trying scuba diving, though he hadn't done any before and he certainly wasn't interested in diving around the cold British coastline. Powell decided to try and set up a 'diving' shoot. Timing was critical. With Daley's exhaustive training schedules, it had to be geared just after the competitive season in the autumn, during a rest period before the winter training began in earnest.

The most suitable venue was agreed to be in the West Indies. Powell approached the *News of the World's Sunday* magazine, which agreed to back the venture. Both photographer and athlete had had previous contact with the magazine, which no doubt helped. Daley's total lack of diving experience presented the first problem. Powell had to convince the athletics governing body, the AAA, and Daley's manager that taking him off to the Cayman Islands for the best part of a fortnight and taking him underwater would be totally safe.

It was a high-risk feature. Risk in the sense that it was costly to set up, with no firm assurances that Daley would take to it or that pictures would result. A London company helped out, sponsoring the equipment, while a local Cayman company sponsored the instruction. Eventually, everything was sorted out and Thompson and Powell, accompanied by their respective girlfriends, jetted off to the sun.

The local diving instructor was Martin Sutton, who kept Daley within the confines of the hotel swimming pool for the first two days, before allowing him in the sea. Life-saving techniques were practised on the beach, much to the consternation

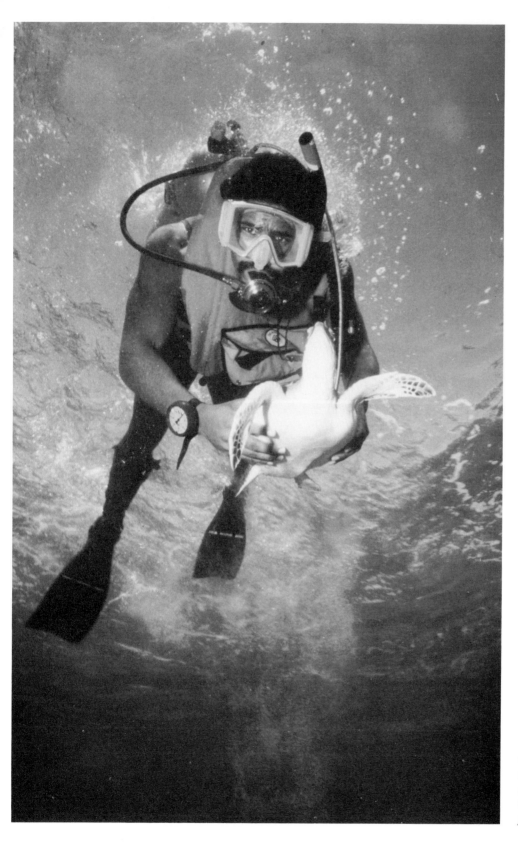

45 *Releasing a turtle into the ocean. A low viewpoint gives the picture depth.*

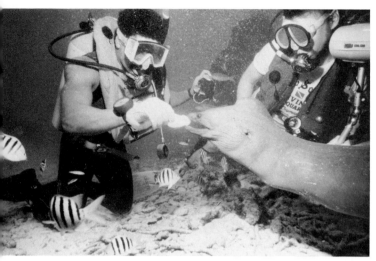

46 (RIGHT) *Pictures taken by Steve Powell on the underwater shoot, which were used by* Sunday *magazine. This picture of Daley up to his waist was used on the front cover of the magazine.*

47 (ABOVE) *Daley feeding the Moray Eel. Only one shot was taken – it was thought too risky to repeat the scene of feeding time.*

of one holidaying American lady, who rushed up to help Daley give his girlfriend the kiss of life on the assumption that there had been a near-drowning. With continued training lasting nine days, competence was increased and Powell, who had been shooting continuously, was able to set up the best shots. These consisted of Daley feeding a dangerous moray eel (lit by flash and used as a double-page colour spread (*Fig. 47*) and a night-time shot of Daley peering into the lens with a shoal of colourful fish filling the frame. Other pictures were used and the magazine chose to run a front cover shot of Daley, waist-deep in the sea with all his gear on with a headline that read: *Superman goes down to the bottom of the deep blue sea (Fig. 46)*. It was a straightforward, upright shot: ideal for the cover. The article stretched over a further seven pages inside.

Shooting underwater presented its own kinds of problems, with a lot of visualisation and pre-planning required. A range of shots was required to make the feature come alive. Powell processed the films at night time after shooting, checking them thoroughly because of the exposure problems underwater. He found that he was getting one or two *real* successes every day

out of several rolls of film. Incidentally, it was Powell's first serious underwater shoot.

As with the winter training shoot, the diving trip provided more than just financial benefits. It was a shared experience, giving photographer and athlete something in common; surely a useful factor for further feature work.

On a purely personal level, it gave Powell the satisfaction of portraying the colour and spectacle of scuba diving in a way that normally doesn't get into the magazines. The usual presentation is that of a high-tech, professional image (which wouldn't ordinarily get into *Sunday*), but Powell was able to present it as the undersea world as seen by everyday people – but it required Thompson's presence. It was a feature about a recognisable person underwater – what he did, how he felt, his personality. It was a combination of two diffuse elements: the decathlete and underwater photography. By combining them – which hadn't been done before – each element bounced off the other to give an unusual, striking and original feature. Anyone who can bring one of the world's top athletes face to face with a moray eel, catch it on film – and live to tell the tale – has got to be on to a winner.

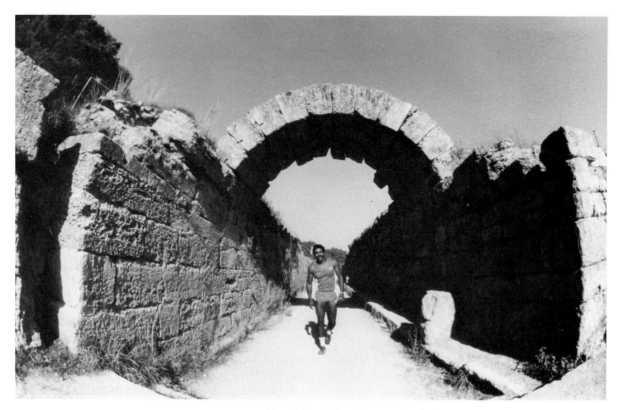

GOING BACK IN TIME

Another feature in which the two have worked together took place in Olympia, Greece, on the site of the original Olympic Games. The shoot was tied in with a video company who were making a film featuring Thompson. Shot in the four days after his European championship victory (when he had broken the world record) the concept was to take the world's greatest decathlete back in time to try out the original Olympic sports. In this respect the decathlon is the purest of the modern Olympic events, deriving directly from ancient times. Powell's involvement was to provide the stills for the film, acting as publicity and, once again, *Sunday* magazine were given the first rights.

The five events from the ancient pentathlon were discus, javelin, standing jump, sprinting and wrestling. Thompson tried the sports to compare them to the modern-day equivalent. He adapted very quickly and understood the old methods. Historians were on hand to give the sporting events accuracy, but the trained athlete suggested techniques slightly different to those they had assumed would be cor-

48 *and* **49** *Two pictures taken in Greece.*
48 *Daley was in Olympia for a video film comparing old athletics with new. This picture shows him walking up the old tunnel, scene of contests thousands of years ago.*
49 (OVERLEAF) *Daley stands tall while all those around him are flat on their backs: taken just after his European Championship victory, which also saw him break the world record.*

rect. Pictorially, the intention was to emphasise the similarities and/or disparities between the old ruins, the old stadium and the modern athlete. In ancient times, the athletes' superb levels of fitness were closely linked with battle and war; modern athletics seems to be becoming a war substitute.

With Daley's continued athletic triumphs, taking him to European and Olympic gold medals – and a world record thrown in – pictures of him have hardly been scarce. Powell and Duffy have continued to photograph his achievements on the track, trying to capture the one picture that sums up the world-beating decathlete. Meanwhile, the magazine world is screaming for anything different on Daley Thompson – but while the world is watching the track, the photographer also looks elsewhere.

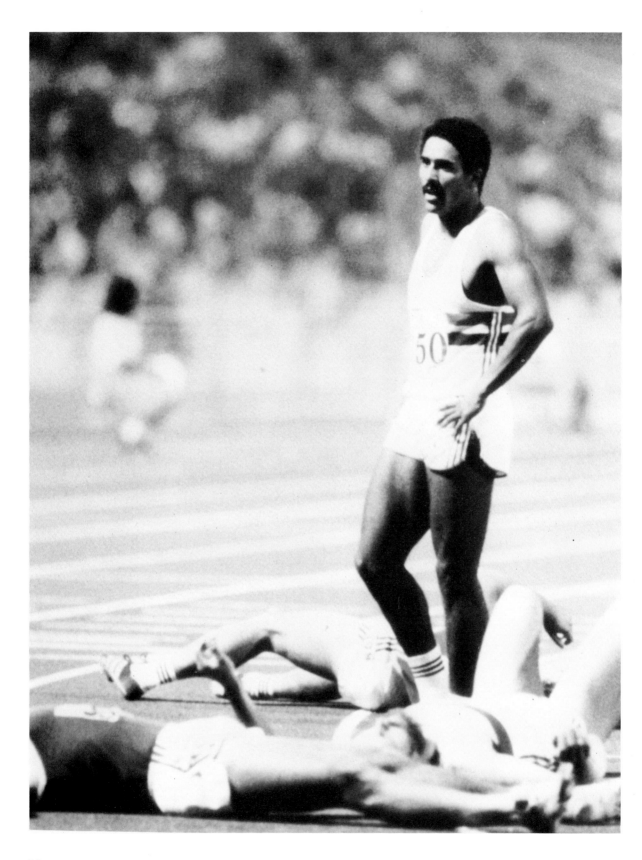

5 On Assignment

ENGLAND CRICKET TEAM TOUR OF INDIA AND SRI LANKA (1982)

Huddled up against the fire in the middle of another long, cold and wet English winter, the prospect of a few weeks shooting cricket in some faraway tropical climate is very inviting. After all, three months away from sleet and snow, three months spent sitting behind a camera, taking photographs of the world's best cricketers can't be a bad thing. Adrian Murrell is All-Sport's cricket specialist. And, of course, jetting off to the sun inevitably meets with cries of envy – especially when, three months later, he returns, with a very healthy sun tan.

That, however, is just one side of the story. Foreign assignments are, if nothing else, replete with aggravations: full of logistical problems; getting pictures back to the UK is just one factor that must be overcome. A dose of dysentery when the temperature is high in the nineties, a succession of inhospitable hotel rooms and more hurdles to be overcome than ever can be imagined by the photographer who hasn't embarked upon such a tour, are all in the background. On the one hand, it isn't a particularly glamorous life; on the other, the problems experienced by Murrell are none other than part and parcel of the overseas photographer's job. It's all swings and roundabouts.

Murrell's cricket photography began

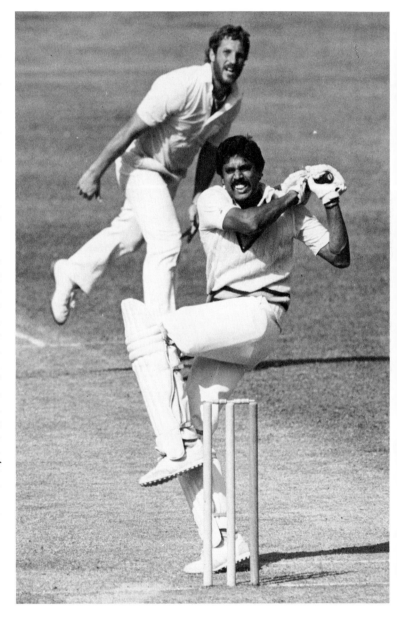

50 *Two of the world's great all-rounders in a single piece of action. Kapil Dev hooks Ian Botham for four in the first test match, which India duly won.*

back in 1976, when he undertook his first tour and worked on a freelance basis for the *Daily Mirror*. The tour went well and, although the trip was regarded as essentially a learning experience, it whetted his appetite to such an extent that tours have followed thick and fast. During that first tour, he brought back over 40 exclusives for the paper. No British photographer had wired pictures back from India before, and England won the series. One of the realities of these tours is that there are only one or two British photographers, a state of affairs that lends itself to scoops. Freelance photographers on these trips are in demand.

Four years ago, Murrell gave up freelancing and joined All-Sport. When he is working abroad for long periods, one of the advantages of working for an agency is that there is someone else back home to keep the business running, handling the job of selling pictures while the photographer can continue to take more. As with everybody else, the freelancer can only be in one place at a time.

The photographer's brief
Planning for this tour, as with all the others, began long before actual departure. There are two main areas to consider: commercial and practical. There's no point going away if there isn't a sufficient market to recoup the costs. Murrell was working on this occasion for five different clients.

1 *Daily Express* The requirement from the daily paper was *the picture of the day* – which might be a bouncer, a key run-out, a punch-up or even a riot. Naturally, it had to be in black and white, and had to be fully captioned and wired within two hours of stumps being drawn, so that it would be on the *Express* picture desk by the time of their afternoon conference.
2 *Hodder & Stoughton* (book publishers) Their need was for 50 black and white pictures, together with a colour shot for the cover of Scyld Berry's book, *Cricket Wallah*. The book was to include action from all the Tests, but primarily to reflect the flavour of Indian cricket from the crowds at the matches to the backstreet games in Calcutta. The pictures were to be presented immediately on return.

3 *The Observer* Published on a Sunday, this paper's need was for a shot of Saturday's action, wired to similar requirements as the *Express*. Also, stock black and white action with Indian backgrounds as failsafe for wiring problems. These were to be air-freighted back. Finally, black and white pictures to illustrate Scyld Berry's weekly column.
4 *The Cricketer* (monthly magazine) They wanted 30 to 40 monochrome, action pictures every week (to include off-beat up-country games), plus colour for three magazine covers. All to be air-freighted back.
5 *All-Sport* We required high-quality colour pictures of each player in all three teams (England, India and Sri Lanka), plus stock batting and bowling pictures every two weeks to update the library. These were all to be sent by courier rather than risk the vagaries of air-freight!

In addition, there were also requirements from magazines in Pakistan and Australia.

Planning the trip
On a practical level, arrangements had to be made for the duration of the stay. Internal flight arrangements were booked in advance, due to the intricacies of domestic Indian flights, none of which leave on time. By contrast, on an Australian tour, Murrell just turns up at airports – it's a cost-saving exercise to travel stand-by. On an Indian tour, Murrell stays in the same hotel as the England cricket team. Problems of sanitation require this. In Australia, there's no way he could afford the £70 per night hotel fees that would have to be paid to stay with the team, so instead he stays in guest houses.

51 (OPPOSITE, ABOVE) *A general view of the England v West Zone of India game at Baroda. The match was played on the private ground belonging to the Maharaja of Baroda. In the top right of the picture can be seen his palace.*

52 *Sunil Gavaskar is mobbed by fans as he scores 150 runs in the second test at Bangalore. The police weigh in unceremoniously. Shooting on HP5 film, Adrian Murrell used a Nikon F2 fitted with 600mm lens plus 1.4 × teleconverter (840mm) and a motordrive.*

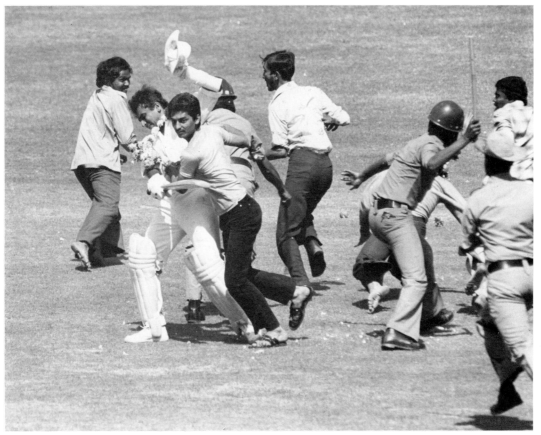

60

In addition, accreditation for all matches needs to be sorted out, together with a complete plan of personal itinerary to coincide as much as possible with the official tour and with existing wiring facilities. Both of these to be organised to maximise shooting time.

Anyway, to cut a long story short, when Murrell took off from the airport he had with him four motorised Nikon F2 cameras (no Nikon servicing in India), a 600 mm f4 'standard' lens, backed up with 300 mm f2.8, 180 mm f2.8, 135 mm f2, 85 mm f1.4, 2 × 50 mm f2, 35 mm f2.8, 24 mm f2, 16 mm f2.8, a heavy duty tripod and battery recharging units. And most of that went as hand luggage – heaven help the person who had to sit next to him! In addition to the hardware, 200 rolls of Kodachrome 64, 300 rolls of Ilford HP5 and the necessary chemicals and tanks to process the black and white. Personal baggage was kept to a minimum – eight tee shirts, two pairs of jeans and, essentially, a suit for official functions. Estimated total weight? – around 70 kilos.

India: wealth and poverty
Arriving in India is something of a culture shock. At Bombay airport, Murrell always finds himself confronted by the uncompromising stench of India. On the way from the airport to the town, people are to be seen lying in the gutter – the untouchables. Children are continually begging. A lot of visitors leave the country without getting over this culture shock whereas, Murrell argues, if you can get over it, you are in for a friendly and hospitable welcome from the Indian people. The country is tremendously beautiful and the smell of Bombay is an intrinsic part of the people and the

scenery. The class structure is very strong. Created by the British Empire, it has remained ever since and the upper classes still live a life of Edwardian England. Most of the top Indian cricket players are from the upper echelons of society – and it's these people that the cricket party encounters while on tour. Wandering around the ground, Murrell would often start the day in the member's enclosure with the wealthier people – the women in their silk saris, pearls and French perfumes – while later in the day he would be close to the public enclosures, sharing a laugh with the locals who would be pelting the pitch from behind their wire cages with oranges, apples, and even their shoes.

While the home of English cricket, Lords, can take only 30,000 people, this is only the size of an average local game in India, with crowds of 50–60,000 amassing for the test matches, and many more shut outside. The variety of the type of spectator gives Indian cricket an unusual aspect, one that has great appeal to the visitor.

The contrast in wealth was particularly brought home by different visits undertaken during the tour. At one extreme was the poverty, exemplified by the sweat shop conditions of a cricket equipment factory in Jullander, northern India. Boys and girls aged six and seven were the youngest of the 200-strong workforce who worked long and arduous hours under the illumination of just two light bulbs. Cricket pads, balls and bats were all made the difficult way – manually. The workers are given a pittance, but they are the fortunate few – there are many without jobs at all.

At the other extreme are the wealthy– the royalty who were stripped of their privileges (but not their money) back in 1963 when Indira Gandhi came to power. Murrell, with *Observer* writer Scyld Berry, visited The Jam Saheb, a Maharajah in Jamnagar, central India. This was to provide source material for Berry's book. The Maharajah's father was none other than Ranjisinhji, the Indian equivalent of W.G. Grace. The two played cricket around the same time.

For this trip, Berry and Murrell were met at the airport by a liveried chauffeur in a 1963 Cadillac (one of two dozen cars owned by the Jam Saheb). They were dri-

53–55 *Various scenes of a cricket equipment factory in Jullundar. The sweat shop conditions are only the beginning of the story: the equipment made here by children aged six or seven (working long and arduous hours) is eventually sold in the UK and Australia under leading brand names. The workers are paid a pittance; mark-ups amount to several hundred per cent until the time when the gear is finally sold in the sports shops.*

ven to the palace, where they waited two days before meeting the Jam Saheb in person. It was an unusual, if not bizarre wait. Apart from the servants, they were the only two people staying in the 400-room palace. It was a 1930's building, and while they slept in solid silver beds, surrounded by old paintings, a silver elephant carriage and numerous jewels, the paper was peeling off the walls.

In an older palace, adjacent to the 'thirties version, Ranji's old bedroom remained intact, unchanged since the day the great man died. His old cricket bats were there, together with a stuffed bird in a silver cage. A painting of Ranji lay on the bed, and in a cabinet was his passport and collection of glass eyes (he lost an eye in a shooting accident in Yorkshire). Ranji's room typified the palace, typified the generation, stuck in a time gap vacated by the British Empire (*Fig. 56*).

Up the creek in Bangalore
With tight deadlines required from the national papers, particularly the *Express*, Murrell was invariably kept busy most days of the tour until seven or eight in the evening. Having photographed the cricket, he would have to process the films and get

56 *Cricketer Ranji's bedroom, left unchanged since his death. On the bed is his photo; behind it is the silver bird cage, together with stuffed bird. It is cleaned every day.*

them wired back. In India, it's always a bit of a haphazard affair. It was usually a case of nipping into a local photographic store and borrowing the darkroom to develop the pictures. The major towns – Bombay, Delhi and Calcutta were suitable as they all had wiring facilities for transmitting pictures back to the UK.

Conditions varied from match to match, but it was the second Test at Bangalore that provided the biggest headaches. And it was the toughest – five days with the temperature in the 'eighties. Murrell's day began at 9 a.m., ready in the necessary position for the 10.45 a.m. start. He had just two hours shooting each day (averaging six rolls per session) as he had to leave the ground at the lunch interval and fly to Madras to wire to the *Express*, Bangalore having no wire facilities.

Arriving in Madras, he borrowed the primitive darkroom of a local newspaper (he used a fan to dry the films and prints) and by 4.30 p.m. would be taking a set of

three prints on a 20-mile taxi journey to the Indians' post office wire point, who then charged £50 for each picture to be sent to the UK. When the last had gone, the *Express* was telexed with details of their shapes and full captions – telephoning was impossible with up to 12 hours delay. After spending a night in a Madras hotel Murrell rose at 6 a.m. for the first flight back to Bangalore, and a motor rickshaw journey to the ground, spent checking equipment and dusting out the lenses and bodies just in time for the 9 a.m. positioning of the photographers' places.

Were the efforts worthwhile? Well, the *Express* was particularly pleased with the Bangalore effort as none of the other Fleet Street papers could compete with their service and consequently had to rely on file pictures. After this Test, Murrell slept solidly for two days.

Which picture?

Working for the various clients proved to be a stimulating and challenging experience. Not only were both colour and monochrome required, but also each of the clients wanted a slightly different shot.

The main requirement for the *Express* was a newsy picture. Technically speaking, it didn't have to be good (the background could be cluttered), so long as the interest was in the day's major incident. The picture was in a supportive role, serving to back up the reporter's copy; it was a bonus if it was also a good shot.

The *Observer* was looking for a good picture. If it happened to tie in with the main news of the day, then all very well. Their main criterion, however, was an eye-catching shot. In many ways, this demand was similar to Murrell's work for the All-Sport library except that it was in monochrome.

As for the specialist cricket magazine, Murrell was aiming to get something a bit different from the other agency pictures. Sports magazines tend to require stock shots of all the players. Murrell normally covers these in the UK in county games, so in India he used the up-country minor matches to get the stock shots of all the players while, during the Test matches, it's the incidents which are the main interest.

The Hodder & Stoughton brief was to capture the atmosphere of India; such pictures as those taken at the Jullander cricket equipment factory (*Figs 53–55*) and Jam Saheb's palace (*Fig. 56*) which underline the extremes of poverty and wealth.

The problem in trying to combine all these different elements is that they will lead to a clash of interest. But a Test match lasts five days. This gives the photographer the chance to shoot in differing styles giving a different client priority on each day. It's perhaps the only sport which allows this.

Murrell keeps on the look-out for unusual angles. He finds that cricket is about shapes, primarily those formed around the 22 yards of the wicket. It might be bowler, batsman and wicket-keeper; it might be a tight cluster of slip fielders around the batsman during a spin bowler's over. He finds himself following the sun during the day, keeping it behind him because, with the players' protective helmets, backlit and sidelit shots look very poor. Also, by changing his position, he breaks the monotony of the same type of pictures. Lords, in fact, isn't a very good ground for photographers, as they are restricted to a single position. He always keeps an eye open for general views of each ground, often using the 50 mm lens for this, which is also used for group team shots.

As for other lenses, apart from the standard 600 mm and 300 mm lenses (actually the 300 mm is effectively a wide angle lens for cricket photography) the 135 mm and 180 mm lenses are used for net practice and the others, down to 16 mm all have their place in the general scenes category. Focusing on the crowds is always worthwhile; Indian crowds specialise in climbing flag poles, buildings and trees.

Survival of the fittest

Apart from cricket matches, life is busy during a tour. As well as the previously mentioned, self-styled developing and printing work, there's an active itinerary. Morale must be kept high for the team to be successful, and the parties are not only for the team, but also for the 15 or so journalists and the one or two photographers – so there's a good camaraderie. There are the inevitable embassy parties, as well as the local millionaires who like to be associated with the cricketers. If the tour en-

57 *An Indian crowd takes up every available place during the one day international at Ahmedabad.*

intensive summer of cricket, golf and marathons. The tour was a sure but steady draining process – both physically and mentally – and he lost over $1\frac{1}{2}$ stone during the 14 weeks.

Experience had taught several lessons. In future he would travel even lighter, though not as far as film is concerned – more had had to be brought out for him during the Indian tour. A box of plastic printing paper would have overcome the time-consuming job of drying the prints by fan every day. A sunhat was essential to prevent sunburn and heatstroke. All the colour film had to be kept in the hotel fridge and, despite 27 internal flights, Murrell insisted on a hand search of luggage rather than risk the film through X-ray machines.

India remains a favoured memory in Murrell's mind. The contrast between rich and poor, the cities and the countryside, all add up to an environment that is unique; one that is, above all, friendly and hospitable.

GOTZIS: HIGH-PRESSURE REPORTING

Not all assignments offer preparation time to consider how you would like to approach the subject, what equipment you'll need or how to communicate your ideas. All too often in professional life creative energy and ideas are used up in just getting to the location, taking pictures and getting out again. That leaves precious little time for creative photography.

The art (and it is an art form) of overcoming the obstacles that often appear to be deliberately set to prevent you getting pictures, however, can be very satisfying. One major talent any successful professional must have is not just technical or creative expertise with a camera, but the ability to convince other people to do what he wants. There is many a young swimmer who shakes at the thought of another photo session with Duffy. And we've heard them admit that one of his photo sessions is like three of their own gruelling training sessions rolled into one. But it is only by the use of his very persuasive tongue that he gets the chance to be creative with his camera.

Sometimes the pressure of assignments

compasses the Christmas period, there are also celebratory parties for that.

At the other extreme, such a long tour can be demoralising. Homesickness, loneliness and depression are inevitably felt from time to time, but, with so much work to do, there's little chance to feel too self-pitying.

Experience can be pretty chequered. Murrell was in Madras when part of the stadium was burnt. Earlier, during the 1978 tour of Pakistan (when Murrell caught hepatitis) there was a riot during the Lahore Test at the time of President Bhutto's imprisonment. The match was abandoned, the stadium burnt and wrecked. Murrell was hit on the head by a stone and it was, overall, a frightening experience. He had all his equipment stolen once in India and has been mugged in the West Indies. An extensive tour of India is only undertaken with the knowledge that the following 14 weeks will be spent with a continual on-off tummy bug – it all goes with the job.

Such tours should only be started with a background of fitness. Murrell embarked on the Indian tour already tired from an

58 *An unusual view of the 80,000-plus crowd at the fourth Test at Calcutta. The raised hands in the foreground give added depth.*

and how the photographer handles that pressure can become a major factor in influencing the pictures. A fairly typical example of a high-pressure assignment started in Wales. Steve Powell had been on the road almost continuously for five weeks doing feature work for *Time Life*'s *Sports Illustrated* magazine. The features were quite varied including Borg in Monte Carlo, birdwatching in Scotland and rock climbing with Joe Brown in Wales. Although physically exhausting, feature work of this nature is very satisfying as it gives one the opportunity to think through the shots and perhaps try something different. With no tight deadline to meet, it's easy to fall into a relaxed approach to the job – waiting for the right weather conditions and extended preparations for one shot are all rare luxuries.

Returning late from a hard day's shooting and climbing, Powell received a phone call from *Sports Illustrated* in New York just before midnight on Thursday evening, late afternoon New York time. Apparently a news story was brewing: all the relevant pundits reckoned Daley Thompson was ready to break the world decathlon record this weekend.

'We want you to cover it'.

'O.K. where is it?'

'Gotzis.'

'Where's Gotzis?'

'Somewhere in Austria. Can you meet Kenny Moore [*Sports Illustrated*'s top ath-letics journalist] there tomorrow – he'll brief you.'

Practical considerations

Knowing very little can be achieved after midnight in a small village in North Wales, Powell packed, checked out at 1 o'clock in the morning and drove to London, arriving back at his apartment at 6 o'clock. While he was on the telephone finding out where Gotzis was and how to get there, his long-suffering girlfriend did the usual: repacked the suitcase, replenished film stock and cooked up a hearty breakfast as it was likely to be the last for some time.

With a very tired 'nice to see you again, darling' peck on the cheek, he set off for the airport. Gotzis, it turned out, was a small village in the Austrian Alps about $3\frac{1}{2}$ hours hard driving from Zurich Airport across the border. After a couple of hours in Zurich arranging shipping details for the film, he picked up a car and headed for Gotzis, arriving around 8 o'clock that evening.

The next problem was to find Kenny Moore and somewhere to stay. Kenny Moore turned out to be no problem. In this small village, with athletes on every corner, directions to the hotel found Kenny tucking into dinner with Daley Thompson. Accommodation, however, proved more of a problem. Small one-hotel towns get a little overcrowded when invaded by all the athletes, media and entourage involved in a major track meet and record attempt. Eventually he found a small hotel in the next village. There was only one problem, which was to prove a major one: it had only one phone, and that was in the proprietor's front lounge. All the guests (and the hotel was full) had to use it. After checking in, Powell joined the queue for the telephone to inform New York of the shipping problems; it took an hour to get through to America.

The only practical and guaranteed way of getting the film to Zurich for the last flight to New York the following day would be to take it himself. Which would mean missing the last event of the first day, the 400 metres. Numerous options were discussed and checked. Alternative airports, alternative routes – what about a

late flight to Paris then Concorde to New York? All the possibilities were examined but they all needed a cut off time of 4.30 on Saturday afternoon in order to get the film back. And then came the crunch: the managing editor had decided he could not hold the magazine open for the second day's shoot. So, somehow, he would have to illustrate the story of a gruelling ten events over two days by covering only four events in the first day – just something more to worry about in the few hours left for sleep. Powell finally collapsed into bed at 2.30 Saturday morning after being on the go since 7.00 Thursday morning – $43\frac{1}{2}$ hours.

The first day

Four and a half hours later the alarm went – time to get down to the stadium for the start of the event. A quick breakfast, and time to sort out the camera gear. By this time the sun was shining – things were looking better already. The 100 metres started the event at 9.00 and Daley had a good one. The day progressed with Daley well on world record schedule and Powell working frantically knowing he had to get enough material out of this incomplete day to illustrate a major story (*if* the record was eventually broken).

All too soon it was 4.30 and time for departure. With the 400 metres still to run that day and the whole of the second day's events missing, he had to be satisfied with what he had taken. In the end, regardless of how good or bad the pictures were, if they didn't get back inside the deadline the whole exercise would have been a waste of time.

Then followed the long drive to Zurich to meet the courier who would catch the last plane to Paris so he could put the film on the Paris Concorde to New York arriving 8.30 Sunday morning, well inside the deadline. The usual doubts crept in: 'Have I misjudged the travel time? What if I hit heavy traffic coming into Zurich? If we miss this connecting flight we miss deadline' (which is the one and only unforgivable sin). All the real hard work had been done, now all he wanted to do was get rid of the film, send it on its way. Well, like any real life story, this particular race ended in anti-climax. There was no heavy

59 *An 85mm lens was used to catch this view of Ian Botham with a stuffed tiger. The picture was printed in the* Daily Express.

traffic and all went smoothly. Steve met the courier and delivered the film with nearly 15 minutes to spare.

After a hurried snack, he drove back to Gotzis secure in the knowledge that the worst was over and he would be able to shoot the next day at his leisure, with no deadline to meet and, hopefully, get a good night's sleep.

The second day

No such luck. On arriving back at the hotel at about 1.30 Sunday morning, the proprietor, who spoke no English, was agitated. He repeatedly pointed at the phone shouting 'New York, New York!' trying to make himself understood. Well, the message finally got across and Powell phoned New York to hear the worst: the 400 metres had turned out to be Daley's best performance of the day. Bettering his previous best by a considerable margin, it would turn out to be a key factor in any story about the world record. There followed a barrage of Questions:

'Did we miss the 400 metres because of the deadline?'

'Yes.'

'Can you pick up coverage from other photographers?'

'Yes, hopefully.'

'Tonight.'

'What!'

'Tonight.'

'Are you joking?'

'No, the managing editor would like you to pick up film and get it to Paris by 6.30 a.m. to ship on Concorde with the other package.'

'But it's gone 2 o'clock in the morning. Austria is shut! Even if I knew where to find the photographers who might have covered it in colour, how am I going to get it to Paris from a little village up in the Austrian Alps in a little over 4 hours?'

And so the conversation continued in similar vein for the next half an hour. Being relayed from managing editor to picture editor to assistant picture editor and, finally, to the poor photographer on site. It's called chain of command, all cleverly designed to make life that much more difficult for the photographer.

All the time these conversations were going on, Powell had the added problem of an irate proprietor trying to get to bed, who was indicating quite forcibly that he wished to lock up and that Powell should go to his room. So, while fighting him off with one hand, he finally received one of those classic one-liners that make managing editors famous throughout the world – 'This is a no budget limit assignment!' Coming from the managing editor of one of *Time Life's* magazines, that means what it says. Unfortunately, unlike New York, nobody wanted to take his money at 3 o'clock on a Sunday morning in downtown Gotzis. Despite a very frustrated plea to the heavens, 'I have a million dollars, somebody give me some film and fly me to Paris', it was all to no avail.

Powell eventually got to bed just before 4 o'clock, having agreed to pick up film in the morning, shoot the second day and arrange, somehow, to get it all back to New York by 8 o'clock Monday morning. They would hold the magazine open: an exercise that costs thousands of dollars.

Seven o'clock Sunday morning – three hours sleep and the pressure is all on again. Breakfast, sort out the cameras and it's started to rain: things don't look quite so good. Arriving at the stadium at 8.30, Powell explained his problems to the Press Chief who promptly offered him a phone and phone book. The Press Chief also told him there was a small sports aerodrome close by that he might be able to use if he could find a plane that would be prepared to land there.

The next five hours were spent phoning and photographing, or photographing and phoning – it all became a blur. Each time Daley Thompson was about to throw, jump or run, Powell would hang up on the phone, leap out of the Press Room, sprint across the stadium and photograph Daley in action. Then tear back again to continue his marathon phone-in.

Daley was also having second day dramas. The weather was closing in, it was cold and certainly not perfect world record conditions. But neither athlete nor photographer let on that they were anything other than the well-oiled, professional machines they like to believe they are; Both got on with the job in hand, one creating the news, the other recording it.

By mid-afternoon, Powell felt he had it beat. He'd managed to persuade the local airport supervisor, the air traffic controller and the fire chief to open the airport between 7 and 9 o'clock that evening to allow his plane in and out again. He'd also managed to find an air charter company in Zurich who just happened to have a Lear jet available. He had contacted the managing director at home during his Sunday lunch and persuaded him that he was serious, not some hoaxer from a hut in the Alps, and fixed a courier to meet him, have the film processed in Paris and carry it by hand on Concorde to New York. That was the plan. Hopefully carrying it out would be as simple as it sounded.

Daley's day was also drawing to a successful, if tense conclusion. After a second day of mixed fortunes he needed a personal best in the 1500 metres to break the world record. Now as the evening was drawing in, the rain was heavy and continuous. Daley brought two gruelling days to a dramatic climax, finishing a spectacular 1500 metres and smashing the old world record, once again establishing himself as the world's greatest athlete.

While everybody else was winding themselves down and getting into a cele-

60 *Keith Fletcher, England's captain, takes his fiftieth test wicket to dismiss Sandeep Patil in the fourth Test at Calcutta.*

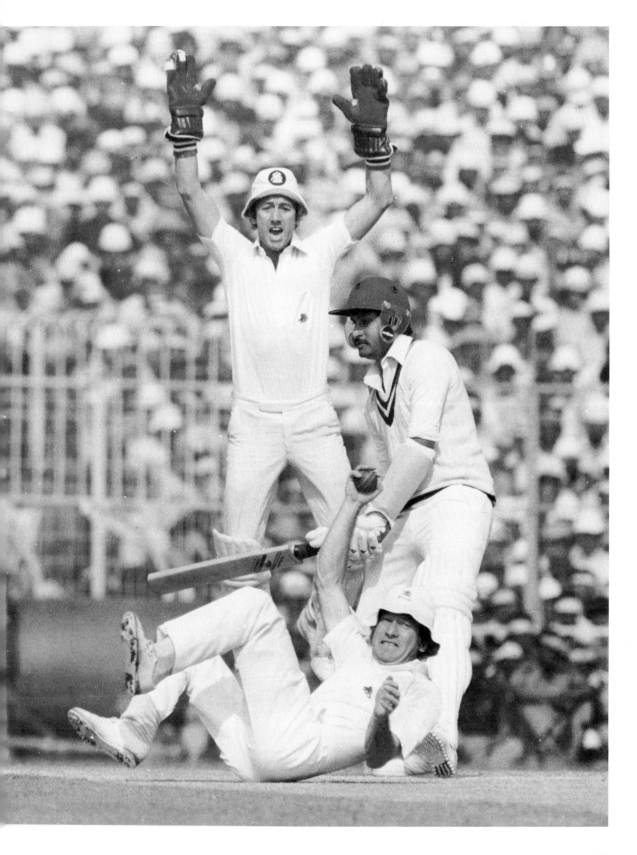

bratory mood, Powell was still on the run. By now totally drenched and exhausted, he made his way to the airport to find, much to his relief, that the airport supervisor, air traffic controller, firemen, local police and a handful of sightseers had all turned up as good as their word. And there, sitting next to a small shed which was the airport terminal, was a very sleek executive Lear jet. No one will ever know what went through the pilot's mind when a very wet and bedraggled apparition in jeans and trainers staggered up and advised them it was him they were all waiting for.

After loading up and taking off he began to relax. After all, all he had to do now was get to Paris and hand his film over to the courier. By now he felt a whisky was justified and sat there sipping it, watching the sun go down. About an hour into the flight one of the pilots turned round and asked him if he had his ticket.

'Ticket?'

'Ja, ticket.'

'Ticket for what?'

'For this flight.' In all the excitement and pressure he'd totally forgotten that when you go around chartering private jets you usually have to pay for them. So, with a flourish he pulled out a string of credit cards and looked expectantly at the pilot who calmly advised him: 'No I am afraid American Express will not do! We don't take credit cards.' Panic set in. In all the rush he'd been unable to get any travellers cheques or any quantity of cash, and had been relying on his credit cards. '72,000 Austrian Schillings please,' said the pilot, 'Cheques!' he said, presumably meaning travellers cheques. Well, Powell worked that out to be two thousand, six hundred and eighty-six pounds and fifty-six pence. He knew he had the fifty-six pence but, as for the rest, no chance.

With images of being thrown out from 20,000 feet with no parachute he slowly pulled out his personal cheque book. Expecting to be stopped at any moment he started to write out a cheque for 72,000 Austrian Schillings. Gaining confidence as he reached the point of signature, he then whipped out his £50 bank guarantee card and formally wrote the number on the back of the cheque, handing it over with all the confidence of the Governor of the Bank of England. There was a long pause as the pilot inspected its every detail. Nobody, surely nobody, takes cheques for that amount with only your word that it will be covered, or so thought Powell, and depression set in. Finally the pilot broke the tension:

'Ja, danke'.

'Great!' screamed Powell, 'Time for another drink.'

The rest of the flight went smoothly. They landed in Paris and handed the film over to the courier who would be responsible for getting it to New York. Steve even managed to cadge a lift to London with the same pilots who fancied a bit of shopping in London. He arrived back at his apartment a little after six o'clock Monday morning, after being on the go continuously for 96 hours, or four straight days, with only seven hours' restless sleep.

The film arrived in New York on time and the magazine was on the streets with full colour report of Daley's achievement by Wednesday morning. The readers would flick through the magazine and perhaps take a second look at the photos before going on to the next article. There was nothing particularly stunning or creative about the photos. They were just good professional reporting. But their publication was an achievement and immensely satisfying.

After sleeping all day Steve drove back to Wales on Monday evening and was ready on Tuesday morning at 7 o'clock to finish his feature on Joe Brown, Welsh mountaineer.

6 When the Going Gets Tough

We all like to see a good sports photograph. Printed full page on the front of a popular magazine, it must have sufficient impact to make us buy the magazine. Whether it's of a skier hurtling down a snowclad mountain slope at 90mph, or a tennis player at full stretch during a major tournament, the picture draws us in because of its ability to freeze a moment in time. It invariably scores because of its simplicity. If a photograph looks too contrived or posed, then it loses its impact; the essence of live action is all too easily lost. First and foremost, we appreciate the technique, artistry or plain gutsy hard work of the athlete; inevitably at the same time we acknowledge the skill of the photographer in capturing that, but the photographer's role is very much in the background.

A good referee at a football match is one who keeps the game flowing such that he isn't noticed, and the photographer is the same. The fact that the photographer taking pictures of the skier might have been on the mountain slope for the best part of a day, with his camera's battery pack stuffed down his trousers so that the batteries won't freeze up with the cold, is immaterial – but that's the bare facts. Let's take a look behind the scenes. First things first. The life of a sports photographer isn't all glamour. The appeal of trips around the globe to exotic places can soon wear off with the aggravation of repetitive hotel rooms, petty customs clerks, unhelpful officials and lousy weather – and that's before the photographer's had a chance to take a single picture.

He can often be called upon to work in extremely hostile conditions. And if he can't get on in them – well, you might just as well have a fireman who doesn't like climbing ladders. Any of the most hazardous environments that sportsmen or women have to face, the photographer will one day be asked to share. And often, because of heavy camera gear and the need for different angles, with added perils. It may be the organised terror of the Winter Olympics in Lake Placid, or the gut-wrenching fear of river racing through bandit-ridden Mexican outback. All Sport has covered both these particular assignments and under these conditions creative thought becomes much more difficult.

WINTER OLYMPICS, LAKE PLACID (1980)

Photographers: Tony Duffy/Steve Powell
Duration of assignment: three weeks
Operating conditions: sub-zero
Subject matter: skiing, winter sports

First, the problems. There's always the preparation before setting out for the games, – tickets, finances, accommodation, passes, processing arrangements for urgent films. Also, the Nikon equipment needed 'winterising', (degreasing) by Nikon to protect the cameras, motordrives and lenses from packing up in the cold weather.

At Lake Placid, the Olympics turned out to be one long series of aggravations for the photographers. With the need for traffic control and the threat from terrorism, no private cars were allowed anywhere near the sporting scenario, making everyone dependent on the system of private buses running between the various sporting centres, covering an area of some 10 miles. Having to wait for buses might

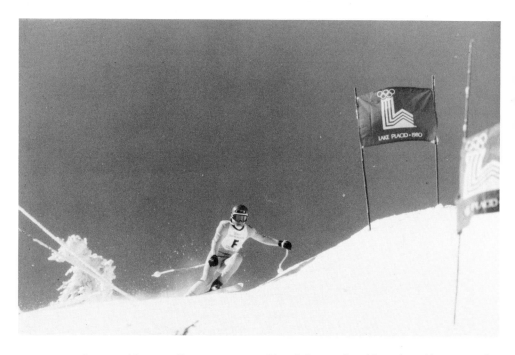

not seem to be a problem until you appreciate that the queues lasted up to four hours in sub-zero temperatures! Powell and Duffy found themselves setting off from their hotel at 6 in the morning to get on the mountain slopes by 11 o'clock. Then, after a day on the mountains it was off to the indoor arenas for the evening's entertainments. No, not a few beers with the journalists, but the ice hockey and skating tournaments.

They would then collect their films from processing, and catch the last bus back, getting to bed at 1 or 2 a.m., ready for the next morning. This is all very well for one day, but has a progressive numbing effect that acts against the photographer's inclination to try to get the very best shots.

The accommodation was inevitably cramped. Originally there were four photographers to a room, but this was later reduced to three. A lot of students, who had been hired as officials, couldn't appreciate the photographer's needs. Halfway down a mountain slope, if Powell thought that a vantage point ten yards further up would give better pictures, he found that the officials weren't disposed to let him walk in a direct line there, but preferred a back route right down the mountain and back up again.

The weather was very cold. Three or

61 *A fast-moving skier, crisp white snow and a clear sky all add up to a powerful image, taken during the Winter Olympics. The skier doesn't fill the frame, but other elements within the picture complement the main area of interest.*

four layers of clothing were essential and, for the hands, three pairs of gloves. An outer, heavy duty pair were removed during picture-taking, but the photographers still took pictures with thermal mitts on top and a silk lined pair against the skin. Powell's Nikon F2 proved invaluable on the slopes, continuing to function when other cameras all around him were packing up because of the cold. That's one of the very definite advantages of the older, mechanical models, as against the more modern electronic ones which have problems in the cold weather.

Even so, as mentioned earlier, power packs for the motordrives were stuffed down the photographers' trousers to ensure they would continue to function, with the attaching cables plugged into the drives. Loading films into the cameras isn't easy at freezing temperatures, with the cold making the film hard and brittle, and with an inevitable tendency to snap.

After two weeks of these continual problems the mind becomes numbed, and

1 *Tony Duffy's photograph of synchro swimmer Alexandra Worisch won the 1982 International Sport Photo Award.*

2 *Duncan Goodhew, Olympic medallist* (Tony Duffy).

3 *The start of a race always presents good photographic opportunities*
– here the 1977 European Championships. The repeating
patterns of the costumes help add to the flowing shapes
(Tony Duffy).

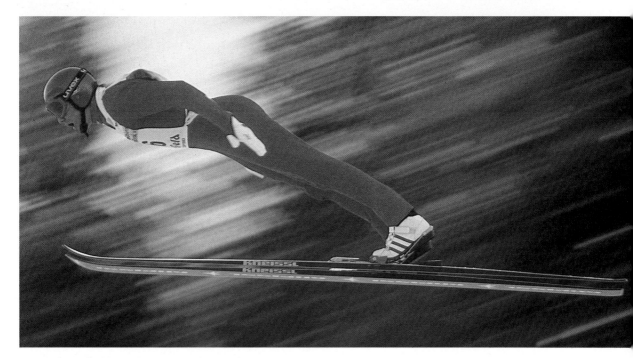

4 *A good example of the use of the panning technique. This ski jumper is frozen, but the background blurs to enhance the impression of speed* (Steve Powell).

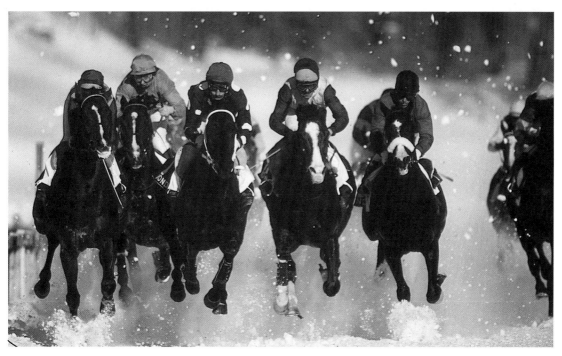

5 *Steve Powell's photo has great impact, yet it is not the sort of impact that finds its way on to the back pages of the newspapers. The fact that the horses are racing on a frozen lake makes the picture unusual and individual.*

6 *A weight-lifter leaps up for joy and is captured by Steve Powell
(World Championships, Moscow, 1983).*

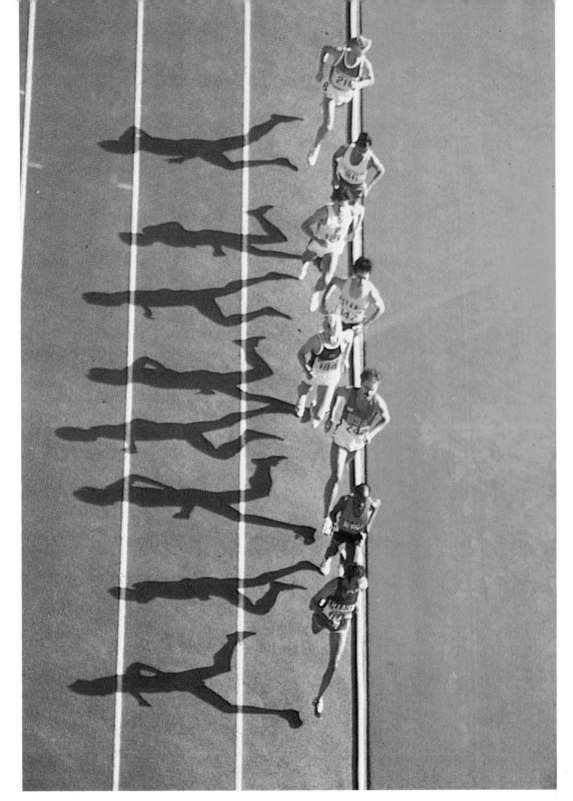

7 *Shooting from above can make an interesting composition. This picture derives from Tony Duffy's observation of figures outlined on Greek vases.*

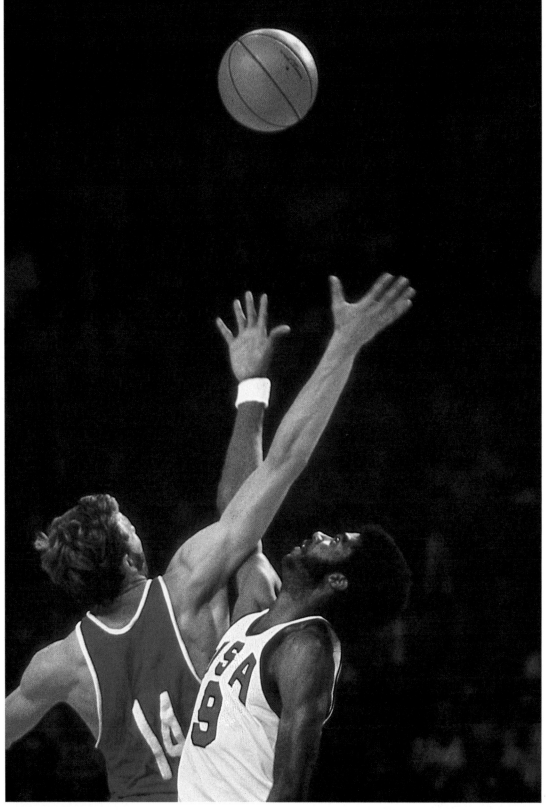

8 *Sport should recognise no distinctions between race, creed or colour. This picture sums up this ideal; not just black and white leaping for the ball, but also Russian (left) and American. The symmetry of this picture is another feature. It was taken during the 1972 Olympic final, which the Russians won in the very last second and which was one of the most exciting finals ever seen* (Tony Duffy).

9 *American football flows all over the pitch and, therefore, requires the use of long lenses. It follows a pattern of set pieces, which can explode into action at any moment, so the photographer must keep his attention focused at all times.*

10 *A set-up shot, but nevertheless one that shows the colour, excitement and intensity of ice hockey action* (Steve Powell).

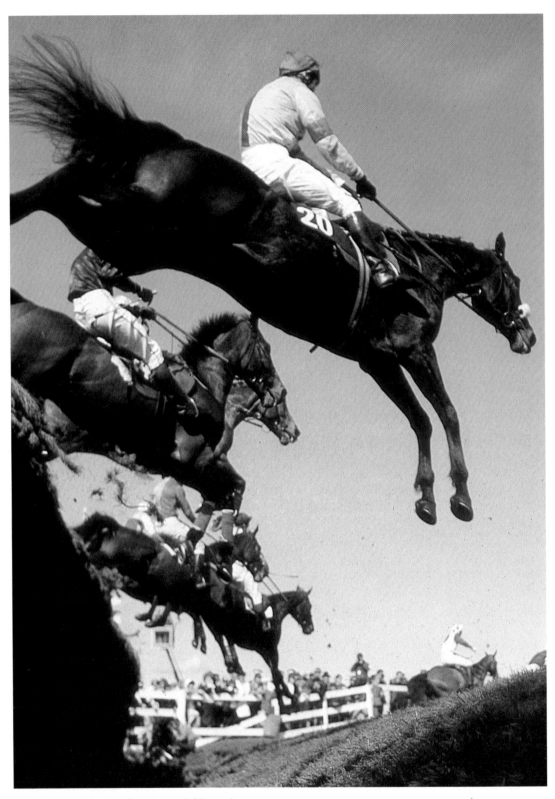

11 *All-Sport's youngest recruit, Mike Powell, follows in big
brother's footsteps; this shot at Beechers Brook during the 1983
Grand National shows the power conveyed by an unusual angle.*

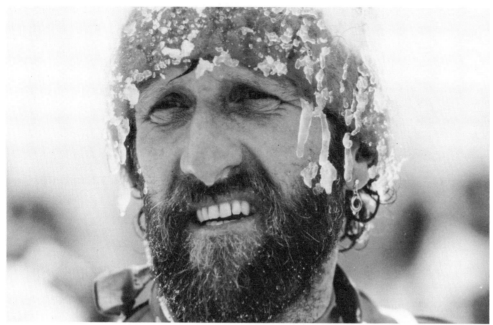

physical exhaustion sets in. It's now that the effort to climb just that ten extra yards for a potentially better angle becomes a major decision of ridiculous proportions. Despite these problems Duffy and Powell made these decisions, working a regular 16-hour day to 'survive' probably the hardest three weeks of their lives.

The only consolation on an assignment like that is the thrill of witnessing the world's greatest sportsmen and women. And, of course, the later satisfaction of looking through the world's newspapers and magazines and seeing that no one else had bettered their photographs. Inevitably, there was little or no news of the difficulties at Lake Placid reaching the public. The massive PR exercise of an Olympic games doesn't cater for such things.

RIO BALSAS JET BOAT MARATHON
Venue: Mexican outback
Photographer: Steve Powell
Duration of assignment: five day race, three days extra travelling
Operating conditions: 100 degrees plus
Subject matter: jet boats

Powell's feature on the Rio Balsas race highlights another aspect of *survival* photography. The competitive achievements of the racers took second place to the story of

62 *The face of this cross-country skier emphasises just how cold it can get during the Winter Games. It is essential that the photographer, if he is to survive several hours in this weather, is suitably dressed himself.*

a struggling band of organisers, press and pit crews battling their way through some of the toughest country in Mexico. It was fine for the competitors – at least they had boats to travel in!

Spending a few days down the river might sound like an enjoyable holiday, but with 500 people camping out every night under communal shelters and a constant stream of local villagers dogging their every step, Powell was continually guarding his camera gear to prevent it from being stolen. He was also physically sick for a lot of the time, largely because of the bugs that are found in Mexico's nether regions. There was no chance of an ice-cold drink – the risk of drinking the water and getting infections was too great. And no water, no ice, so all the drinks were lukewarm.

The meals, prepared by the Mexican army on field kitchens, were basically inedible, and, combined with the general conditions, there was little appetite for food. At night-time, it was simply a case of

63–66 *Scenes from the Rio Balsas jet boat race.*
63 (TOP) *The crew of* Coatzymoto *negotiate rapids using oars in addition to the boat's motor.*

64 (ABOVE) *Boat Number 341 is managing fairly well, but still needs the bucket for essential baling out.*

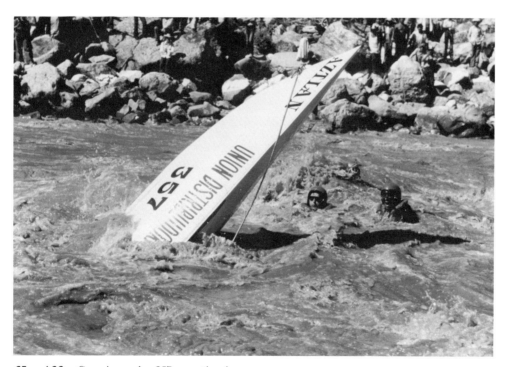

65 *and* **66** *Come in number 357, your time is up. These two pictures show the end of this particular boat, which just goes to show that when the going gets tough, not everybody gets going.*

camping out by the side of the mosquito-infested river. Apart from the minor irritations, there was the more important problem of bandits, but this was overcome by the Mexican army, who escorted the whole ensemble and protected it from possible attack.

The photographers followed the race by land and by helicopter. On one occasion, the helicopter dropped Powell and a TV crew by the river at 8.30 a.m. Sandwiched between the river and the desert under an intense sun there was no cover to provide shade. The boats powered through at around 11 o'clock, and, 20 minutes later, had all gone. Unfortunately, the helicopter pilot, in his excitement, had forgotten about his passengers, who were then left by the river in the searing heat until someone noticed they were missing. They were eventually picked up at 4.30 that afternoon.

On another occasion, Powell and a few others were dropped in by helicopter at a night camp. Three boat crews also turned up, but no one else, leaving a small group of competitors and photographers stranded for the night. They wandered into a local village, witnessed a shooting incident and high-tailed it out again, to be picked up the next morning.

Apart from the heat and trying to keep films cool, the major photographic problem became the sand and dust which got everywhere, and there was no real chance to clean out the cameras and lenses, so they became encarcerated in dust until the assignment was over.

The whole of the Rio Balsas course stretched over a thousand miles. Out of the 74 starters, only 26 made it to the finish, indicative of the tough and unrelenting nature of the event.

OVERCOMING THE CONDITIONS

These two assignments – Lake Placid and Rio Balsas – typify some of the extremes that the sports photographer can expect to come up against sooner or later. Environmental problems like these have to be overcome, but it's a fact of life that they have the effect of wearing down the photographer's resistance, acting as a stumbling block against creativity. In the Rio Balsas race, all the jet boats passed through in a matter of minutes, and the photographers were then dependent on the available helicopter to catch them further down river. The problems were beyond their control and there was little choice – nobody *wanted* to be stranded in the middle of nowhere. But in Lake Placid the photographers *had* a choice – it was up to them how far they pushed themselves in order to produce creative photographs and, in this respect, Lake Placid presented tougher environmental problems than Rio Balsas.

Undoubtedly the greatest problem was the intense, numbing cold. When the conditions are rough, it's surprising – or perhaps not surprising – just how quickly the brain will convince the photographer how good the ordinary, standard, *safe* pictures are. But, despite the conditions, the photographer must continue to function and not accept the basic shot: he must push himself that little bit harder – that's the mark of a good sports photographer and is what differentiates him from the studio worker.

It comes down to a case of determination and self-honesty. Don't lie to yourself by accepting the first and easiest option when everything is screaming at you to do so. Trying to look for something a little bit more imaginative is always more difficult than the standard shot – especially when the elements are piled up against you.

The best way to stop the brain's weakness taking over is to work continuously. You need the ability to carry on shooting despite external environmental and internal illness problems. It also opens up more opportunities: the more pictures you take, hopefully, the more ideas will come. It's at times like these, when creativity is 99.9 per cent perspiration and 0.1 per cent inspiration, that the really good photographer will recognise these symptoms and push beyond them to get imaginative pictures despite the conditions.

7 Put It on File

An essential part of any photo library is the ability to have rapid access to transparencies or prints. When requests come from outside sources, or you're trying to compile an editorial feature, it goes without saying that it's a great asset to have pictures ready at short notice.

How they are filed is a matter for individual taste. But, apart from the obvious A,B,C, method where pictures are filed under their respective sports heading, it is often useful to create different categories. The All-Sport library, for instance, has feature sections on losers, comedy, accidents and injuries, left-handers, fashion, and so on. The library might have a hundred shots of Jimmy Connors but if there is just one humorous one of him, it makes sense to put it in the comedy section for ready access.

The next few pages give a selection from the All-Sport library, not as a strict guide, but as a suggestion. The pictures chosen fall into general areas and have been listed accordingly.

SHOOTING SEQUENCES

While 35 mm photography is primarily concerned with still images, don't overlook the potential of a sequence of photos that tell a story. There are several on the All-Sport files. If good, they have a strong market potential. A motordrive is essential,

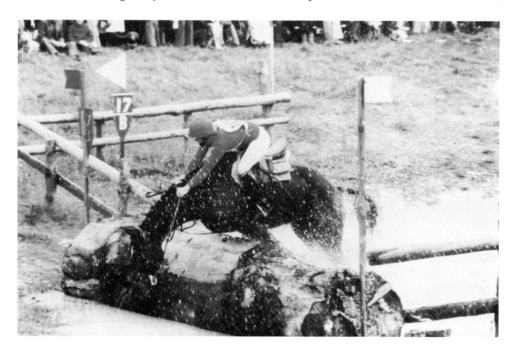

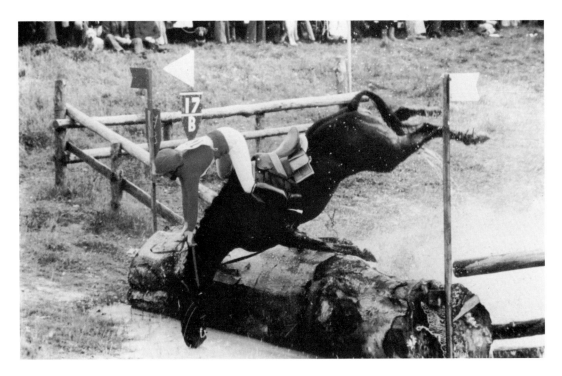

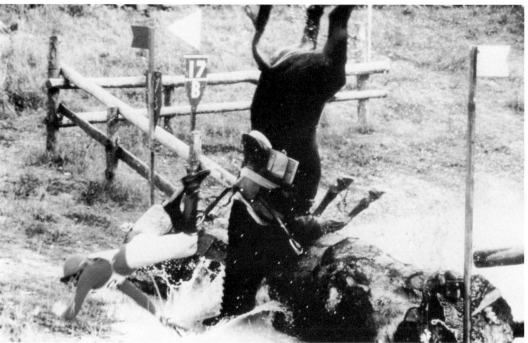

67–71 *The water-jump series by Tony Duffy. Miss J. Winter, riding Stainless Steel, takes an early bath when the horse decides enough is enough. Both horse and rider are dumped unceremoniously in the muddy water. She broke a collar bone, but the horse came through unscathed.*

with a speed of five frames per second generally being adequate.

Cross country horse trials are always a favourite among photographers, because of the inevitable disasters that crop up at the water jump (*Figs 67–71*).

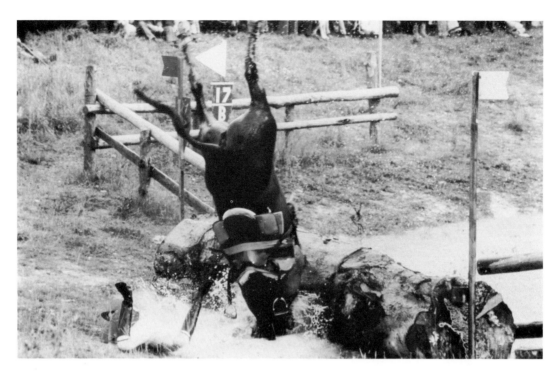

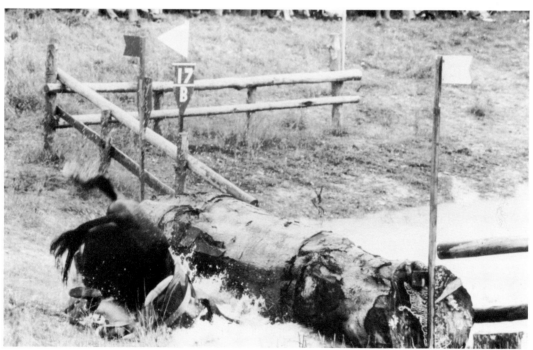

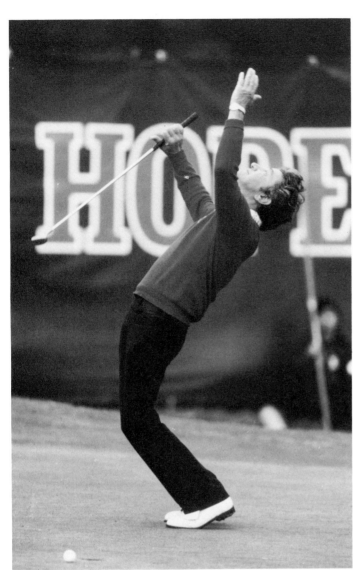

KEEP YOUR EYE ON THE BALL

When photographing ball games, it's not essential to include the ball in the picture. That said, it never harms the image to have it in view. It's the cream on the cake and tells, very simply, the story of what's going on (*Figs 72–76*).

72 (LEFT) *Gus Savalas missing a simple putt. Notice how the photographer has juxtaposed the anguish evident in the golfer's reaction with the background word – HOPE. The picture was taken during the Bob Hope Classic tournament.*

73 (RIGHT) *Russian ice hockey player Vladyslaw Tretiak comes face to face with a flying puck in this scene shot by Tony Duffy. Only by using a long lens and closing in on the action, has he been able to capture the moment.*

74 (FAR RIGHT) *Found in the back streets in Brazil, this young man shows all the skill and control that has made Brazil the world's most exciting footballing nation.*

75 (OPPOSITE, BELOW) *Laurie Cunningham, an England winger of outstanding talent, executes an overhead kick against Queen's Park Rangers – and he scored!*

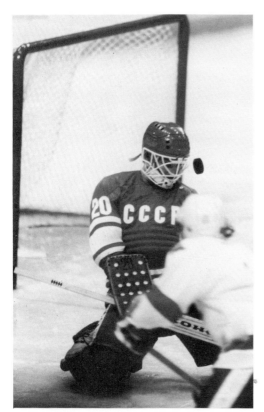

76 *At first glance, this isn't a striking picture – until you look closely and see Tony Neary's face popping out from the scrum. Action like this is very rare, so be prepared for every eventuality.*

COMICAL CUTS

A sense of humour is never a bad thing, whatever walk of life you find yourself in. Humorous sporting moments are increasingly few and far between. So, when they are captured, they must stand a greater chance of commercial success (*Figs 77–81*).

77 *Brother and sister, John and Tracy Austin, hug one another during the Wimbledon tournament. The contrast in sizes makes this picture come alive.*

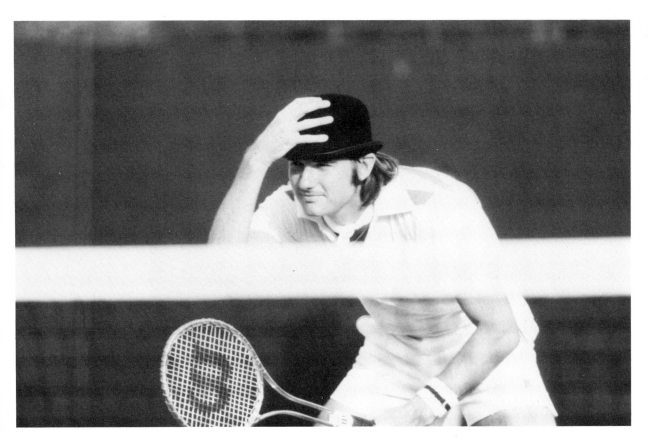

78 (ABOVE) *Jimmy Connors in 1975, trying on a hat for size. Adrian Murrell snapped up this view.*

79 (RIGHT) *Tony Duffy got down low for this cheeky shot of Betty Ann Stuart, the lady remembered for falling out of her dress. 'Watch it' says the caption, which says it all.*

80 (FAR RIGHT, ABOVE) *Whatever it was that just happened, it must have been funny. Lee Trevino shows his appreciation in this picture by Tony Duffy.*

81 (FAR RIGHT, BELOW) *Great sporting pictures are often sublime – so keep an eye open for the ridiculous. While all the hefty divers head for the sea, the seagull remains unimpressed. A picture like this often needs cropping, so it requires some visual awareness from the photographer in the first place – in this instance Steve Powell.*

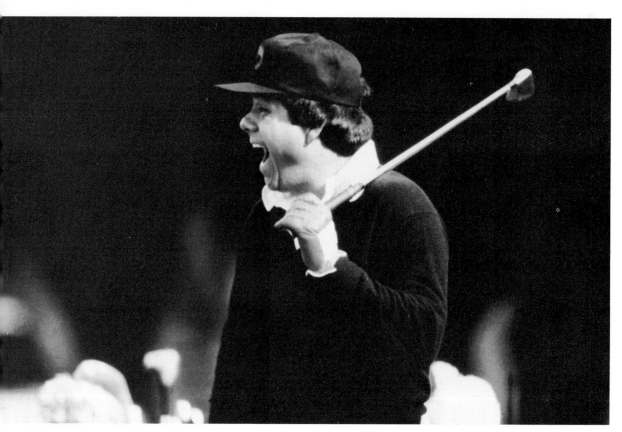

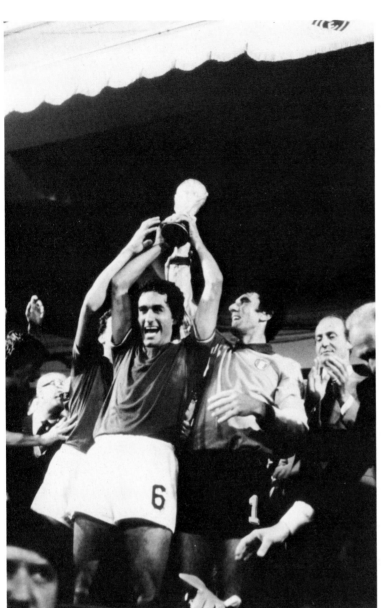

GREAT SPORTING MOMENTS

Every contest brings its winners and losers. They are there to be captured on film. Catching them is important, not just for immediate coverage in magazines, but for longer term use. If there is a 'key' shot in an Olympic games, the chances are that, four years later, at the next games, that shot will be in demand. In the very long run, historical books will want these pictures – so never under-estimate a picture's potential life-span (*Figs 82–88*).

82 (LEFT) *The joy is evident on the faces of Italian players Zoff and Gentile as they hold the World Cup aloft. The matches were held in Spain and the Spanish king, Juan Carlos, can be seen adding his own appreciation in the background.*

83 (OPPOSITE) *Montreal Olympics, 1972. Canadian Julie White clears the high jump bar in front of an enthusiastic audience. Both hands are aloft; it's almost as if she can't believe she's succeeded in clearing the bar.*

84 (OPPOSITE, BELOW) *Nowhere is happy emotion more evident than in football, where every goal is sufficient for the players to jump for joy. Here, former England star Kevin Keegan races to the crowds, arm aloft, having just scored an important goal against Scotland.*

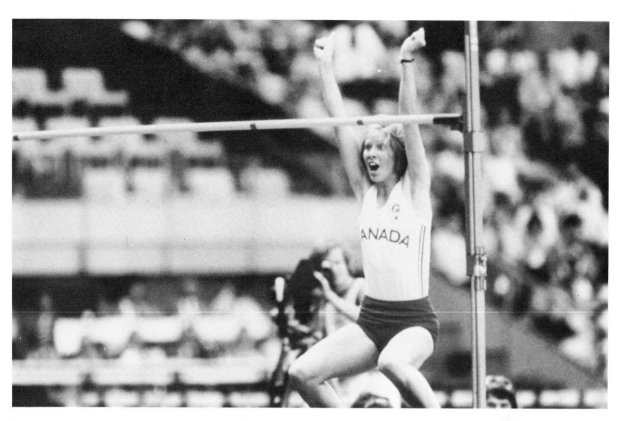

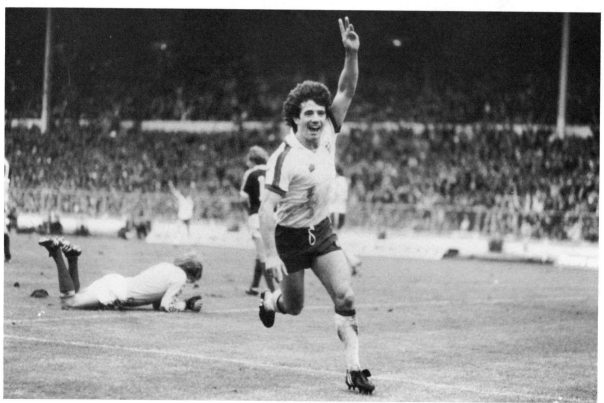

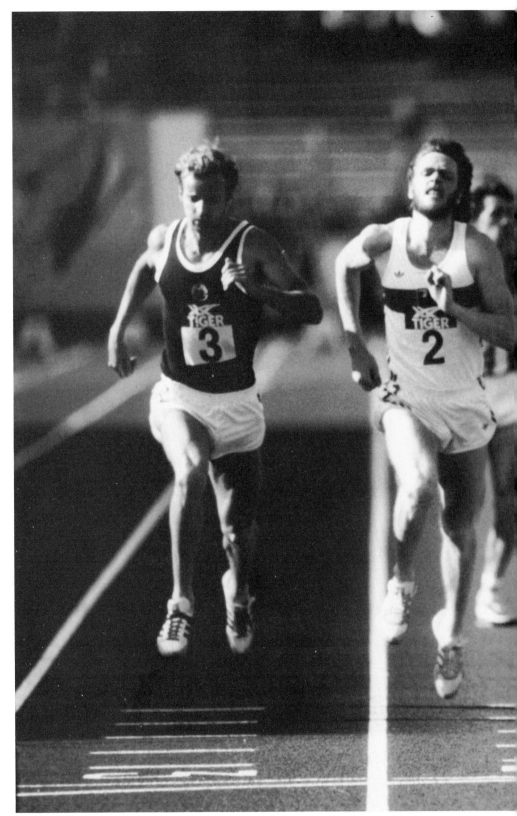

85 *Sebastian Coe wins the Europa Cup 800 metres. The determined effort on the face and the clenched fist say it all. But not every winning picture is so photogenic.*

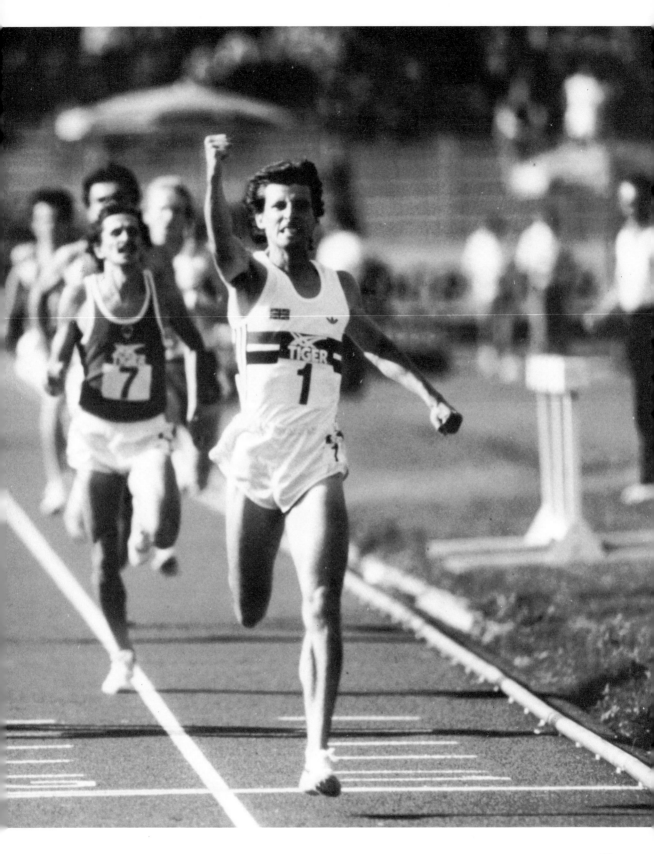

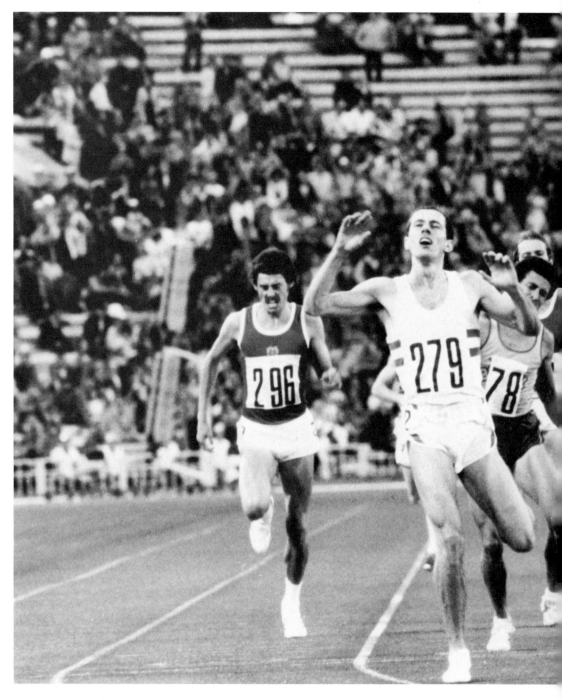

86 *The 1980 800 metres Olympic final. Ovett is the victor, relief creeping over his face at having won. His rival Coe has the defeated look, while the Russian on the right is concerned to see if he has won the bronze. A great deal of emotion is portrayed in this picture.*

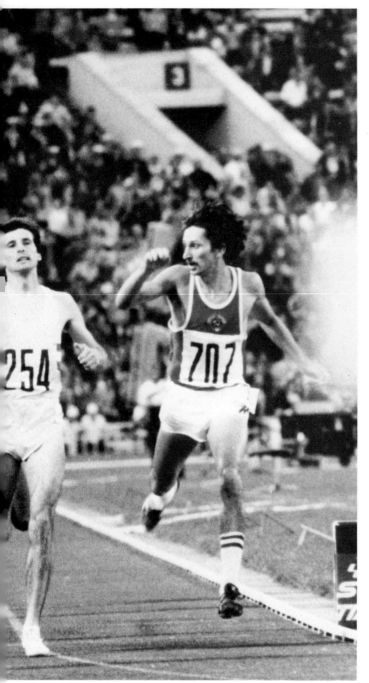

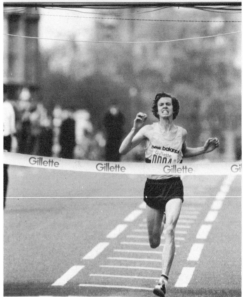

87 (ABOVE, RIGHT) *Hugh Jones completes
the first London marathon. It was the fastest
ever in the United Kingdom, and Steve Powell's
photo captures his time. Note the taut expression
on the face, reflecting the runner's grim
determination throughout the entire length of the
marathon's 26 miles, 385 yards.*

88 (RIGHT) *Russian swimmer Salnikov raises
his hands aloft, having just won the Olympic
1500 metres freestyle event.*

BLACK OR BLUE

When shooting outdoors, it's remarkable just how effective a blue sky is, transforming a dull sky into one that is not only colourful in itself, but also heightens the colour of the subject being photographed.

Indoors, such advantages are never to be had. However, with some forethought and help from the stadium lighting, a black background can be created, as in these four shots. The darkness helps concentrate attention on the sportspeople, heightening the drama. All the pictures, apart from the one of Barber and Slater (flash), were taken by available light, requiring the use of fast film (*Figs 89–92*).

89 (BELOW) *Tony Duffy caught this action shot of Lise-Marie Allen during an ice skating routine. The lighting highlights the girl's outline and you are left wondering how on earth she got into that position – let alone got out of it.*

90 (OPPOSITE) *Table tennis player Liang Ke Liang keeps his eyes on the ball in this serving shot. The ball is, in fact, an essential part of the photo.*

91 (FAR LEFT) *World conquerors Torvil and Dean captured in graceful harmony during one of their highly popular and successful routines. A cross screen filter has turned the point of light into a star, making full use of the frame.*

92 (LEFT) *Lit by flash, Barber and Slater strike a graceful pose in the mist.*

WOMEN IN SPORT

Sport has been one of the key areas in the development of recognition of women in an egalitarian society. Don't forget that for many years women were barred from competing in long-distance races, and have gradually been allowed to take part in 3000 metres, 5000 metres and the marathon. Indeed, modern physiologists and sports fans are noticing that, while women don't have the absolute speed or power of men, their capacity for endurance and recovery is remarkable, making them very suitable for long, tiring events where stamina is essential. The pictures selected here, give just some idea of the way in which women have risen to prominence in sport (*Figs 93–99*).

93 (BELOW) **Power.** *This Canadian competitor grits her teeth in sheer determination, during the world powerlifting championships.*

94 (RIGHT) **Concentration.** *Lining up for the shot. This competitor combines a steady hand with a sharp eye during the 1972 Munich Olympics. Physical differences between the sexes are brought to nought in events like these.*

95 (FAR RIGHT) **Mobility** *Javelin thrower Fatima Whitbread in action at Crystal Palace. This sport isn't just about hurling a spear, but requires co-ordination of arms and legs to achieve the best possible distance. Also essential are power and sprinting speed.*

96 (RIGHT) **Grace.**
Suzanne Dando in an artistic pose. Such pictures work best with women athletes.

97 (FAR RIGHT) **Sport for art's sake.** *Rachel McLish demonstrates a pose which suits her sport, body-building. This has taken off in recent years and Rachel has had the distinction of being world champion.*

98 (FAR LEFT) **Speed.**
*Rollerskating isn't just an
easy way of getting around
if you don't drive a car. It's
become a sport in its own
right and Sandra Dulaney is
a speedskating world
champion.*

99 (LEFT) **Skill.**
*Waterskier Karen Bowkett
executes a bit of trickery
while travelling at high
speed.*

ONE STEP REMOVED

Pictures that depict either the peak of action or sport with tremendous impact are inevitably images that spring to mind. But don't under-estimate those shots that record the subject in a slightly different manner. We're not talking about pictures that feature remarkably original angles, or show the subject in a novel manner. What we are considering are those shots slightly different from the majority, which catch the eye simply because they are one step removed from conventionality (*Figs 100–103*).

100 *and* **101** *Two pictures of the start of backstroke races – with two entirely different effects.*

100 (OPPOSITE) *A long lens homes in on the action, isolating one and a half swimmers in an unusual manner.*

101 *By contrast, a more distant view features the swimmers making an interesting arch as they kick off from the side.*

102 (RIGHT) *An impressionistic result is achieved by zooming the exposure in this basketball shot.*

103 (BELOW) *Sand-dragging. A wide angle lens is sufficient to close in on the action, showing the driver and car in relation to the landscape.*

WATER, WATER EVERYWHERE

Never under-estimate water as an ingredient in a photo. Its mere presence in a shot adds to the impact. Particularly during the summer, when the weather is warm and many people are going on holiday, there is a demand from magazines for pictures having a summery feel – and what better way is there than to show some water sports action (*Figs 104–107*)?

104 (RIGHT) *Juxtaposition of images in this picture of the London Inflatable Marathon. Contrasting the dinghies with the Houses of Parliament makes this picture far more interesting than if the dinghys had been shown without such a photogenic backdrop.*

105 (BELOW) *This photo by Steve Powell scores because it is unusual – the man taking off from the ramp without any skis on. Shooting from a low angle emphasises the barefoot sport.*

106 (ABOVE) *Cowes week. A telephoto lens concentrates attention on the busy sea.*

107 (RIGHT) *Closing in with a long lens shows this canoist in high-speed action.*

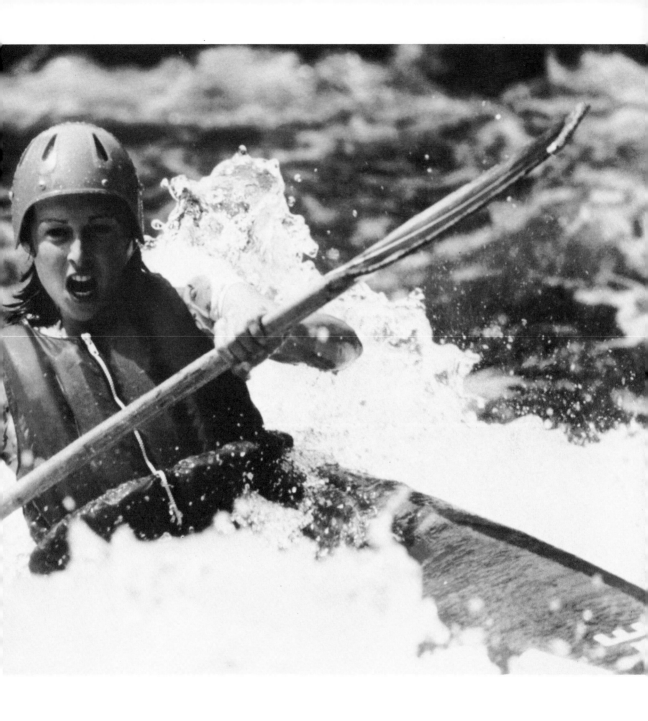

FINDING FORM

Form is one of those indescribable things in a picture: but it either has it, or it doesn't. Each of these pictures has its own kind of form (*Figs 108–112*).

108 (BELOW) *Baseball: all the essential ingredients are there.*

109 (FAR RIGHT) *The Rumania four man bobsleigh team in action. Taken from a seemingly impossible angle, the camera has frozen the high-speed action. The camera's position gives the picture both depth and drama.*

110 (RIGHT) *Czechoslovakia and the United States meet on either side of the animated referee in this symmetrical picture.*

111 (BELOW) *This high jumper fills the frame and, together with the bar, creates stimulating angles.*

112 (FAR RIGHT) *Adrian Murrell's picture of fishermen has a simplistic quality. Overall, a relaxing photo that is very successful.*

8 Tackling Different Sports

INDOOR SPORTS

The first major hurdle to be overcome is lighting. Too often, there's not enough of it and it's of the wrong type. Sort out beforehand whether the lighting is balanced for tungsten or daylight, and choose your film accordingly; usually the light is artificial.

Position is important. At many competitions, photographers are forced to shoot from high up in the gods. While this might initially appear remote, it can have advantages. In gymnastics, for example, it allows the photographer to shoot in such a manner that the athlete is isolated from the background and taken against the floor. If shooting is possible from ground level, then get down low to increase the dramatic effect. Also, such an angle allows the photographer to use the stadium lights to effect, with a backlit, rim-lit effect. This can be emphasised by perspiration – once the boxers or basketball players have warmed up a bit, the perspiration will shine, adding to the pictures.

Particularly with a sport like basketball, a low viewpoint is advantageous to emphasise drama. Nearly all the 'real' action takes place around the baskets, so some of the best shots can be had from a cluster of players leaping to the basket. Alternatively, a more unusual view is to shoot

113 *Isolating the subject concentrates attention on that subject, with no distracting backgrounds. It is a particularly effective technique in a sport such as gymnastics, where grace and artistry are vital ingredients. Tony Duffy, helped by the lighting, keeps full attention on Russian gymnast Nelli Kim.*

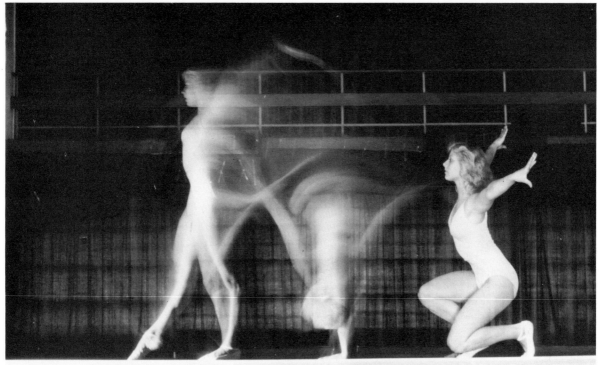

Continental Sports

114 *Suzanne Dando, as seen during a long exposure through Steve Powell's lens. Slow shutter speeds allow the photographer to manipulate the image in this manner.*

from directly above the basket, catching the players as they leap up with the ball. Much of the beauty and athleticism of top competitors can only be really captured by shooting them at full stretch in this way. Similarly, the grace of a gymnast; television can give an overall view of the dramatic motion, but only a photo can freeze the action in mid-air.

If the light level is too low to stop the action, then perhaps a shot of the static competitor in a graceful pose may be the best compromise. Flash is obviously not allowed during competition, but there's nothing to stop the photographer organising a photo session in private. By doing this, and being able to control the variables (lighting and positioning) then much more dramatic and graceful pictures can obviously be achieved.

Steve Powell created his own gymnasium, utilising a private photo session with UK gymnast Suzanne Dando to manipulate movement during a photo. By using very slow shutter speeds, the blurred outline of the gymnast was created, moving through a three-second backward move-

114 *Suzanne Dando, as seen during a long exposure through Steve Powell's lens. Slow shutter speeds allow the photographer to manipulate the image in this manner.*

ment. She started from a standing position, and then rolled back to stand on her hands and then continued the motion until in kneeling position once again (*Fig. 114*). A very long exposure captured this blurred routine and Powell, keeping the shutter open, put the lens cap on the camera. With the gymnast in her final position, the lens cap was removed, one flash exposure made and the shutter closed. This gave an unusual and original view of the gymnast's routine; one which scored because it presented the complete movement in a manner not normally seen by the eye.

When you're not in control of the setup, as is the case during competition, then knowing the sport is very helpful. Indeed, with gymnastics it goes beyond this – a knowledge of individual routines can be critical. During a competition, each competitor works through a number of set

115 *An all-England team competes against an all stars team in this netball shot by Steve Powell. While the game is in action, the judge presented an uncompromising view for the photographer. The lights at the top of the stadium ensure interest is retained throughout the whole of the picture.*

SOCCER

Soccer's emotive, high-speed action has made it the world's most popular team sport. At both international and domestic levels each season produces a crop of surprises, winners and losers, and the inevitable controversy.

The worldwide demand for soccer shots is inexhaustible, both in the immediate sense – goal-mouth action for the daily newspapers – and a longer term requirement, more likely to be for colour, of individual players from the top teams.

Positional sense is important, though there are no great secrets. Either go for goal, to highlight the intensity of goal-mouth action and penalty area incidents, or opt for a touchline position – the edge of the penalty area and the half way line are the favoured positions. It's a case of practical common sense – and compromise. Settling down near the goal or on the halfway line gives the photographer the luxury of choice. For the goal-mouth photographer, a long telephoto lens can be used to focus on the midfield action, while an 85 mm or 100 mm lens is better for shots near the goal. Similarly, the photographer on the halfway line can utilise different focal lengths to keep in touch with play all over the place – and catch the action at *both* goals.

Obviously, knowing the sport helps – adopting a goal-mouth position is only a good investment if there will be some action around that goal. Also, run through the match programme for any exciting players. If a position on the half-way line is chosen, make sure it's on the same side as the skilful ball players. If one of the teams has a good winger, the ball will invariably be given to him to take up the line and then cross for the strikers to hit the back of the net.

Metering can be difficult, but won't present any real problems if common sense is applied. In the autumnal, sunny days, avoid shooting into the light. So, if it's a clear day, check out the sun and estimate where it will be towards the end of the match. Some football grounds are notorious for low sunlight. The sun itself is not the only problem. Long shadows cast by the stands throw a lot of the ground into deep shadow, giving a dark cast which acts

routines and within these are a few key elements where he or she is at full stretch. Knowing when these will occur is a great help in capturing the peak of the action. Sometimes, the gymnast will practise the routine prior to the competition, so watching the athlete and learning the key moves will set you up for the competition itself.

Other indoor sports vary greatly from gymnastics. Weight-lifting, for instance, is largely static. Try to get away from the straightforward view by juxtaposing the competitor with a nearby scoreboard or, after the lift, keep focused on him – success brings jubilation and failure leads to despair, both of which tell more of a story than a simple shot of a guy with weights above his head.

114

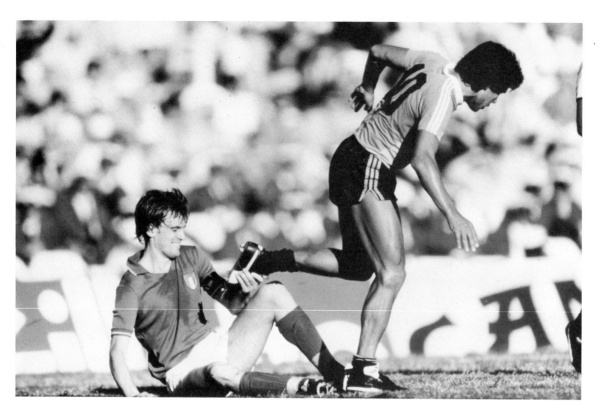

116 *While goal-mouths inevitably bring the peak of the action moments in soccer, shooting from a halfway position allows you to home in on most of the action with a long lens. A long lens shows Italian Marco Tardelli giving an ungentlemanly tug to an Uruguayan player's boot.*

against the photographer working in colour.

In winter, the poor light offered on a miserable day only lasts half the match; with early nights, the floodlights come on at half time. These make colour photography very difficult – not because of the light balance, but because of the dim lighting, which means it is necessary to up-rate films considerably. Late spring and summer give better opportunities, and bright sunlight particularly is conducive to fast lenses and slow films.

Not all the best action takes place on the ball. Look out for the elation of a team that's just scored, or dejection of the losers. Penalties are always a good time – not exclusively for the ball hitting the net, but

perhaps some of the players who cannot bear to watch. Sending-offs can always be relied on for an unusual shot. Taking this idea a step further, turn away from the play to the crowds with their colourful scarves and banners. Scotland's tartan is particularly photogenic (*Fig. 117*).

MOTOR SPORTS

As shooting motor sports has become very popular, the major pitfall to avoid is one of repetition. This is particularly the case with races that take place around a fixed circuit. While there's always a demand for shots of the top 20 Formula One drivers, the creative photographer is always looking to move beyond the straight record shot that merely depicts a particular vehicle captured sharp on a tight bend. This is invariably the favourite position – so look elsewhere. Perhaps a long view looking up the main straight might be a good bet. Using a telephoto lens, a bunch of cars is easily compressed together to make them appear in close contention and this compression can be enhanced by a steep bank of spectators directly behind the cars.

It's easy to overlook the fact – parti-

117 (ABOVE) *Scottish soccer fans on their bi-annual jamboree to Wembley for the match against the auld enemy. Always keep an eye out for these shots.*

118 (LEFT) *Northern Ireland racing driver John Watson in the final stages of preparation prior to a Formula 1 Grand Prix. Shots like this one, taken by Tony Duffy, say a lot more about the nature of the sport than some of the action shots might. The fireproof suit and balaclava emphasise that the man is merely an extension of the machine.*

cularly with high-speed motor sports – that sports photography is not just about the action, but also incorporates other important elements. Close-up studies of individual drivers preparing themselves for the race have proved to be very popular with the world's magazines. This has emphasised the de-humanisation of the drivers in modern day Formula One racing, where the man is little more than an extension of the machine. The pits offer good scope: not just the drivers in the final state of preparation, sitting in their finely tuned cars

in the last, nerve-wracking minutes before the start, but also the bright, colourful, gleaming machinery which provides a natural and striking scene for the colour worker.

Exploding a zoom during exposure is another worthwhile technique, although it has now been fairly well used and can be hackneyed. Even so, zooming with the car as the centre of interest, the bright colours can be streaked across the picture, giving a powerful image. An impression of high speed is easily obtained by panning with the action – although the background is still important. If there are advertising hoardings or colours behind the cars, these will be streaked, and the colours give extra texture to the picture. There's nothing to stop the two being combined – zooming and panning at the same time – but by this time the picture is getting so complicated that it might just be time to pack up and go home.

Bad weather, so often seen as the photographer's worst enemy, can be used to good effect. Get in low, avoid a distracting background (sky is often the best background of all) and catch the spray from the car as it approaches at high speed. There aren't too many sports where rain can be used to complement the image in this manner. Spray will also give an indication of the speed.

Most circuits for racing are self-contained, the most notable exception being the Monaco Grand Prix, with the annual jamboree bringing all the Principality to a halt. If shooting there, try to juxtapose something of the race with the local street scenes – some pre-planning is needed, but the results will be worth it.

OFFSHORE WATER SPORTS
Powerboat racing and yachting may be minority sports, but they are, nonetheless, growing in popularity, with greater media

119 *Powerboat racing in Bristol docks, 1978. The competitors taking the bend in tight formation has allowed Steve Powell to catch the intensity of the action; the water spray emphasises the speed.*

awareness and a band of dedicated enthusiasts.

Powerboats can be raced either within the confines of a set area – such as the Embassy Grand Prix in Bristol docks – or further out in the open sea. The former case is better for the photographer in that he can choose a dry, firm base from which to shoot on solid land. Ultra long teles are the order of the day, together with sound positional sense. As with 'dry' motor sports, the bends are naturally photogenic. However, more dramatic pictures can be obtained from the spray which emphasises the boat's speed. Bends can be very tight, and shots of two or three on a bend simultaneously add depth and excitement to the pictures (*Fig. 119*).

Moving offshore to the ocean powerboats and yachts, the photographer is battling with the elements to try and get his pictures. As the race is so remote from the shore, he is left with three possibilities: boat-to-boat, helicopter-to-boat or on the competing boat itself.

A small, mobile and versatile dinghy is very useful for photographing yachting events, particularly with a skilful pilot to look after the craft while you are shooting, but never for powerboat racing because of the risk of collision. A valuable technique is to move in close, shooting with a wide

120 (ABOVE) *Ocean racing. The crew of the yacht* Ocean Greyhound *are kept busy all the time. A wide-angle lens was necessary to encompass all the elements on the boat, together with the sea, which helps give a sense of perspective.*

121 (OPPOSITE) *Shooting from a boat to one side, Steve Powell caught world champion skier Mike Hazelwood in impressive action in 1977 at Ruislip lido. The 500mm lens gave very limited depth of field and isolated the figure against the spray backdrop. Only one shot was taken. The photographer had to anticipate the moment of sharpest action as the skier was moving too fast to follow focus.*

angle lens. This will fill the frame with the sails, and the distortion caused by such a lens will emphasise the billowing sail. Using a longer lens, action shots of the crew within a section of the yacht are valid to capture the tense action onboard. As the crew often wear bright yellow waterproofs, this is a particularly attractive subject for colour.

Shooting from a helicopter allows the photographer to move in very close. This is useful for powerboat races, but yachtsmen won't be too happy with the wind

caused by the helicopter. When shooting from a boat or helicopter, keep shooting at high speeds in order to account for the vibrations. Of course, the greatest problem with helicopter photography is the simple one of cost – so it's probably only worth trying once a year at the most.

The third alternative is to get on board the racing boat itself. This is a viable idea on a yacht, as long as you don't get in anybody's way. An extreme wide angle lens will come into its own here, capturing the crew in relation to the craft and to the sea (*Fig. 120*). With the vast expanse of sea, sky and brightly coloured sails, metering can be a bit tricky with automatic cameras. A rule of thumb is to open up one stop from an automatic reading, but this doesn't cater for variations between a sunny and a cloudy day, or even the sensitivity of the camera meter.

SKIING

The traditional image of skiing – that of glamorous, brightly coloured skiers hurtling down clean white slopes against a clear blue backdrop is all very well – but it doesn't always work out that way. Skiing can present tremendous environmental problems. Apart from the problems of clambering up steep slopes and then standing around for several hours with the tem-

perature well below freezing, grey days can take the top off attractive scenes. A skier against a dull, grey sky doesn't have quite the same impact as one against a clear sky. Try a graduate filter to re-introduce some colour to the scene.

Position is important. With long, downhill courses, there will be little or no opportunity to switch from one side of the course to the other once the competition has started. Obviously, some of the best angles will not become apparent until you're in position – so pre-planning might help. Don't forget the position of the sun as well, and make sure you take into account its movement across the sky during the day. A knowledge of the venues is important in this respect. Most ski runs are deliberately positioned on north-facing slopes to reduce the possibility of the snow melting on a sunny day. This keeps them in the shade most of the time. There are a few south-facing slopes and these offer better photographic settings, especially for colour.

Metering is inevitably problematic. If your camera has a built-in light meter a rule of thumb is to take a reading off the snow and open up the aperture by one and a half stops, although this will vary from camera to camera. An alternative is to take a meter reading from skin tones.

122 (LEFT) *An unconventional shot of freestyle skier Uberall, simply because there's no snow! The low position serves to emphasise the skier's height.*

123 (OPPOSITE) *Track and field presents the photographer with enormous scope. The start of the 100 metres in the Commonwealth Games presents an unusual, frozen study of athletes as they push forward from their blocks.*

To sum up, skiing is all about crisp, clean whites, deep blue skies and the colour of the skier's clothing. You'll often have to climb above the tree-line to find the skyline. Keep an eye open for the inevitable bumps on a slope, where the skier flies through the air, to give added drama to your picture.

ATHLETICS

If nothing else, athletics – or, more specifically, track and field – presents a logistical problem for the photographer. With two

or three events taking place concurrently, the simple fact is that you can't be in more than one place at any one time. However, only one of these events will be on the track while there will be several field events running simultaneously and each field competitor has several bites at the cherry: with the jumps there are six rounds, for the throws either three or six attempts, and with the high jump and pole vault the contest continues until each competitor has had three failures at a particular height.

With careful organisation therefore, it should be possible to cover a wide range of events, just by following the timetable and switching from one to another. This sort of approach only has real benefit for collecting 'stock' shots of all the athletes and isn't a sound proposition if you're just trying to cover one or two of the athletes.

Shooting the field events requires discretion, simply because the click of the shutter and the whirr of the motordrive can be distracting to the competitor who is trying to psyche himself or herself up. A

124 Stephen Niklaus, decathlete, is caught landing in the long jump pit, spraying sand all around him. Laying the camera on the ground, Steve Powell pre-focused it at a specific point of the pit where he expected the jumper to land, and then fired the shutter at the time of impact.

long telephoto lens is very useful, distancing the camera from the athlete so as not to intrude, while the limited depth of field throws the background out of focus – useful for concentrating attention on the main subject. So far as track events are concerned, the finish line is obviously the favourite choice. So try for an angle that will give the best results. Keeping fairly low emphasises the height which the athletes reach during running. Pre-focusing on the finishing tape ensures that you will get maximum sharpness at the critical moment. As an alternative, pick up the runners a couple of metres from the end and continue to shoot them with the motordrive – the sequence may produce some

useful shots. Head-on pictures of the finish reveal the look of victory on the winner's face contrasting with the despairing grimaces of the also-rans. Follow them through after the finish for the expressions.

Facial features are very important in athletics photography, with the competitors putting 100 per cent effort into the race. So don't be afraid to use extremely long lenses to pull the faces up and catch their contorted expressions. Apart from the finish line, a lot of the action in middle and long-distance races takes place on the last turn 100 metres from the end – many runners choose to make a break for the tape at this point and explode into action. It's worth knowing the tactics of the various athletes and preparing yourself accordingly.

One of the prominent aspects of track shots over the past couple of years has been the search for an unusual angle. Ultra-wide angle lenses positioned low to the ground as steeplechasers take the water jump is just one example; other photographers have opted for a high position in the stand and have made interesting compositions with the shapes and shadows of runners and the layout of the track marks. While these have appeal for their originality, they can become over-used and clichéd, but no doubt future events will continue to produce even more new angles.

GOLF

There's at least one professional who shoots all his originals on Kodachrome and under-rates it by one-third of a stop. The reason for this is that he finds this under-exposure helps to re-create rich greens on the duplicates – and it's mostly duplicates that find their way into magazines.

Golf is one of the few ball games where the click of a shutter can upset the competitor; it doesn't matter in football, is generally acceptable in tennis, while in cricket the photographers are so far away from the wicket that they can't upset anybody. Discretion is very much the better part of valour, so use long lenses to avoid interfering with the play. Each hole witnesses a repeated pattern of action, craft and mental concentration in three distinct elements.

Action

The tee shot gives the photographer scope: it's possible to capture the golfer at full stretch, having just hit the ball. From the feet through the body to the hands and then to the straight club provides line and extension; filling the frame with this picture gives a dramatic shot.

Craft

Craft is evident as the golfer plays a chip shot towards the green. A good position from which to maximise this shot is from the back of the green. Often, the golfer will be slightly below the level of the green and you can get an interesting shot by capturing him or her, club up high, ball in the air, and concentration on the face. If the golfer is in a bunker, then spraying sand is an added bonus (*Figs 125 and 126*).

125 *and* **126** *Two shots of golfers playing chip shots towards the green.*
125 *Japanese golfer Isao Aoki is just one element in this shot. Carefully framed to include the flag, sand, ball and the facial expression. All are important elements in the shot.*

126 (ABOVE) *Taken from a similar angle as 125, Dave Cannon chose to exclude the flag and present the golfer, American Nat Crosby, in relation to the spectators in the background. They're all interested, which is more than can be said for the dog.*

127 (OPPOSITE) *Cycling on circuits can range from the sublime to the ridiculous; the intense action is sometimes broken by the competitors practically coming to a complete halt. This shot, taken during one of those slow moments, makes an interesting composition.*

Mental concentration

Finally there is the green itself, where mental concentration is uppermost, as the golfer considers all the angles before making the putt. Don't forget to keep focused on the player after the putt has gone in - or missed. Expressions can tell the whole story in a split second.

CYCLING

Apart from races in a tightly-banked, confined circuit, cycling takes place out on the open road. Most events are either straight races (first one past the post wins) or time trials, with the competitors taking off at one minute intervals. With distances of up to around 160 km (100 miles), there's a lot of potential for the photographer - and a lot of ground to cover. So it's best to sort out priorities early. A car is essential to catch the best of the action. Try perhaps a general shot of the start, and then a nippy drive 8 to 16 km (5 to 10 miles) up the road to catch the leading bunch as they come through. Look for positions that offer good shooting possibilities. Inclines for example, are useful as you can focus on the leaders and have the chasers in the background, toiling up the hill.

Head-on shots, either during the race or at the finish, benefit from a long lens. With a 500 mm or 600 mm lens, the photographer can get into a good position to catch the leaders and then move smartly out of the way before they come through. This gives him a little bit more of a safety margin. Furthermore, the long telephoto will compress the cyclists together, making them appear far more tightly bunched than they actually are.

If you are travelling independently in a car give yourself enough time to get to the finish. There will often be large crowds and traffic restrictions - and there's nothing worse than sitting in a traffic jam, arguing with the local gendarmes, while the leaders overtake you to get to the finish.

SWIMMING

Competitive swimming imposes very severe restrictions on the photographer. Not only is he confined to his shooting position, but the sport gives nothing to him. The swimmers dive in at one end, swim up and down for a specific number of lengths and then finish at the end from which they started. That's it. It's true that sprinters in a running race also stick to similarly enclosed channels, but at least they're not in the water and the expressions on their faces can be captured. Swimmers are more concerned with getting oxygen into wide open mouths.

Good pictures are still, however, to be had. The extension of a row of bodies as they spring for the water at the start provides a dynamic photo every time. As a variation on this theme. Duffy has experimented with this and captured a row of women swimmers in mid air (*colour plate 3*). Some are higher than others, some more advanced across the frame, but the hands and legs are hardly there – it's a shot of torsos, with the various costumes adding colour.

Don't forget the backstroke, with the swimmers practically coming out of the water as they kick off from the side. Don't stand on a line with the edge of the pool but aim for an area 2 to 3 metres (6 to 10 feet) into the length – this will be at a good position to cover the bodies at maximum extension.

During the race, a long lens to pick out faces is required. Front crawlers will be turning their heads to the side to take in air, while breast-strokers and butterfly specialists will be looking to the end – so choose your camera position carefully, according to whether you want them head-on or in profile.

The finish itself isn't particularly striking, but the moment of victory just after touching can yield excellent shots. Also, some tanks have glass walls, allowing photographers unusual angles from below the waterline.

TENNIS

The way tennis has developed in the past few years has worked against the photographer. Many of today's top players prefer to play on the base line, from where they can control the game without having to over-exert themselves in full stretch very often. This makes for boring pictures which lack great extension or action, and even the player's personality is subdued. However, to make the best of a repetitive

128 *A study of Tracy Caulkins during a breast-stroke race. A long telephoto lens was needed to focus in on the action.*

129 *Spanish water polo star Manuel Estiante caught at full stretch, about to lob the ball.*

game, perhaps the best shot to be gained on the base line is of the player about to make a backhand stroke. The ball is in the picture, to act as a key element, and the player, about to strike, has harmonious balance and extension.

When a player *does* come close to the net, there is the potential for some explosive action. He or she will often be at full stretch, and a good angle from which to shoot is from a position just above the net, to highlight the leaping antics.

Because tennis takes place within a small arena, players' emotions are amplified and are under close scrutiny from cameras. Footballers can swear and shout, but usually they are so far removed from spectators and photographers that a lot of their temper goes unnoticed. But in tennis, with the two gladiators the focus of all attention, these tantrums or explosions can become key elements in a game, particularly if they state something about a top player's personality.

Apart from the action, keep a look-out for other, off-court pictures that will make good feature material: ballboys and ballgirls, umpires, crowds in the rain with umbrellas up, general scenes – all are worth putting in the library files. Wimbledon, with its long tradition, is particularly good material for these atmospheric shots.

AMERICAN FOOTBALL AND RUGBY

These are games from opposite sides of the Atlantic that are increasing in scope and appeal in this country. They have striking similarities with each other, the predominant feature being the fact that the length and breadth of the pitch is covered. To get the maximum from either game requires detailed knowledge. Both games incorporate ritualised, stop-start set piece actions. Each of these can develop in several directions, and the photographer must be able to read the game in order to anticipate possible eventualities.

Action is mostly followed from the touchline down the side of the pitch –

130 *Ilie Nastase lunges for the ball at Wimbledon.*

131 *Martina Navratilova looks as if she wants to play hide-and-seek rather than tennis. Adopting a low position and shooting just over the net gives this unusual and effective angle. When players are close to the net, off-beat shots will occur.*

although the photographer can set up at the ends of the pitch – and inevitably, most photographers work with the light behind them. Following the action up and down the touchline requires mobility, so the photographer is well advised to keep his equipment to a minimum. That said, the nature of the game dictates that long lenses are required, to home in on the mid-field action. As with so much in sports photography, it's a case of compromise: trying to find the happy medium between a lightweight bag and sufficient long lenses.

9 Techniques and Equipment

TECHNIQUES

Competitive sports impose severe restrictions on the photographer. He may be consigned to an isolated position a long way from the action; he might have to cope with artificial light; he won't, in most cases, be allowed to use flash; he might have to argue with unhelpful officials; he might have difficulties to get an accurate meter reading; he might be in amongst 30 other photographers who will all be getting largely similar shots. The list of problems goes on and on.

In order to overcome these obstacles it makes sense that the greater the photographer's skill and the range of techniques at his disposal, the better equipped he is. He might have the best 35 mm equipment going, but unless he can put it to its full use, he won't be justifying its cost. This book assumes that you have the basic understanding between lens aperture, shutter speed and film speed, and can control these variables. That's the beginning.

Pre-focusing

Pre-focusing isn't just about setting up the camera on a tripod, focusing the lens on the finishing tape and then pressing the shutter when the first runner breaks the tape. In the split-second between the runner crossing the line and the photographer firing the shutter, there will have been some movement, and so the photographer will have missed the key shot. Anticipation, coupled with a knowledge of the sport, is critical. Anticipate the exact moment of crossing the line – get a feel for the sport and for the camera.

Pre-focusing is essential with high-speed action, where follow focus isn't possible. Unlike running, where there is a convenient finishing tape, many other sports aren't so specific, so this anticipation should be coupled with a knowledge of how the action will develop – where it will be at its peak.

If you are following focus which is the easier method, then make sure you are focusing in the same direction as the subject. If the subject is heading straight for you and you are focusing the other way, then the chances of an unsharp picture are vastly increased.

Stopping the action at fast speeds

Unless some care is taken when stopping high-speed action, the picture can fall flat on its face. Using a high shutter speed to arrest movement is fine, but the trouble is that it can create the impression that there was no movement in the first place – especially if the background is sharp.

Imagine two photographs of a motor-cyclist. Both are taken at fast speeds and all movement is frozen. The first motor-cyclist, travelling at 30mph, is sitting upright, leaning ever-so-slightly into a bend. The resulting picture has about as much panache as if the bike had been parked. Now take a second motor-cyclist, travelling at the same speed. Get him to crouch right down, low over his bike. Make him rest the tip of his toes on the pedal bar, so that his knees are brought sharply up under his face. Get him to put an exaggerated lean into the bend. The result? A far more dramatic picture, one that creates a sense of speed – even if there was hardly any in the first place.

A valid way of emphasising the action at fast speeds is to shoot at wide apertures. This throws the background out of focus, concentrating attention on the subject. By using a smaller aperture, the background also becomes sharp, stopping movement.

Stopping the action at slow speeds

Panning is the name of the game here. By choosing a shooting position from the side (as opposed to head on) and using a speed between 1/15 and 1/60 second, the photographer can freeze the movement of the subject, but turn the background into a blur. The technique is straightforward: pick up the subject as it moves across the shooting area; get it in the centre of the finder and follow it through, ensuring it stays in the middle; and, when it's reached its best position, fire the shutter – but follow through with the camera. Otherwise, if the camera movement is stopped, it's likely to jerk the camera, giving an unsharp picture. Backgrounds with some points of bright, coloured light can be particularly useful as they turn into streaks, giving a colourful picture.

Panning with cyclists or runners at speeds of 1/15 or 1/30 second can give more dramatic pictures. The speeds used are so slow that there will be some movement from the runners' legs or the wheels of the bicycle.

Exploding the zoom

While zooms have found great favour with amateur photographers, they have not really made much inroad into the pro's market. They offer the flexibility of various formats, but lack the basic fast apertures of specialist, fixed focal length lenses. However, they do offer the photographer the opportunity to use an unusual effect, termed 'zoom explosion'. This is created by zooming the lens down its focal length during an exposure. This causes streaks of light to emanate from the main subject. The technique is as follows: set the camera on a tripod for a slowish speed; pre-focus the camera and, when the subject is just about ready to be photographed, begin moving the zoom along the focal length scale; halfway there, press the shutter. The photograph on the front jacket shows a good example of this technique.

Linear slit

While panning can create the impression of speed, there are times when it is insufficient. This technique employs the use of a linear slit on the front of the lens and is used when trying to give an impression that a static subject is moving at high speed. Why should this be necessary? Well, there are occasions when the subject cannot move – perhaps through mechanical fault. Or, the light might be so poor as to rule out a picture with a slow-speed, fine grain film. In this instance, a land yacht was the subject. On the day of the shoot, the light was low and there was no wind at all – rendering the yacht motionless.

This technique, shot at a slow speed, starts with the photographer mounting the camera on a tripod. The subject is then placed against as colourful and complicated a background as possible to create the impression that it is moving at high speed. Using a long lens (the longer the better) to distort the background the photographer tapes two slides across the front of the lens, leaving a narrow vertical slit. Metering has to be carried out through-the-lens, as not much light is getting through. Keeping the subject sharp and in view, the slit is then rotated to create a panning effect on the background, making it blur.

This was the technique used by Powell in the shot of the land yacht (Fig. 134). It was stationary. The driver was positioned to look as if the yacht was moving at some speed. Then, to add impact, Powell pulled the top of the yacht towards him by means of a rope, to make it look as if it was leaning in. As a final touch, the back wheel, which was in the air, was spun to create added sensation of movement.

Flash

Indoors, flash photography is not of much use, unless you can control the environment, which is not the case at a competition. Outdoors, where flash is possible it presents a problem. While the flash will freeze the subject into one picture, there will also be a ghosting outline of the subject lit by available light. There are two ways round this. Firstly, the photographer can under-expose the available light part by shooting with the flash on full power;

however, this is only practical under very dark conditions. Secondly, the flash can be used as a basic fill-in to an available light exposure. Most cameras, with a limited flash syncronised speed of 1/60 second, will require the panning technique, but Nikon's FE2, for instance, allows flash synchronised at 1/250 second.

EQUIPMENT

Having the right equipment doesn't make the photographer any better, but it does allow him to extend the picture-taking opportunities. Not every piece of equipment is needed for every job – it too easily leads to lumbago and a trip to the physiotherapist – but the more there is to choose from, the more pictures can be gained.

Cameras

At least two camera bodies. One can be for monochrome, the other colour, but a spare is essential in case one breaks down. They invariably do go wrong from time to time – always at the critical moment. Arguments are rife as to whether mechanical cameras are better than the elec-

132 *and* **133** *Panning and zooming are useful techniques that can up-grade an ordinary scene into a striking one. Both techniques are used in these shots of athletics competitions: panning in the case of the sprint start, and zooming at the steeplechase water jump.*

tronic ones, but it's largely a case of personal taste. Modern types often have electronic control with mechanical back-up speeds if the batteries fail. The so-called 'professional' SLRs – Nikon F3, Canon F-1, Pentax LX, Contax RTS – are geared up for heavy duty work and should take considerable punishment. Don't expect expensive, more amateur-orientated models to take the pounding of day-after-day work in the pouring rain.

Meters

A hand-held light meter is an essential tool. Most of the SLRs available today only offer centre-weighted metering, which is fine for general scenes but not much more. A light meter taking an incident light reading is vital for 'tricky' light-

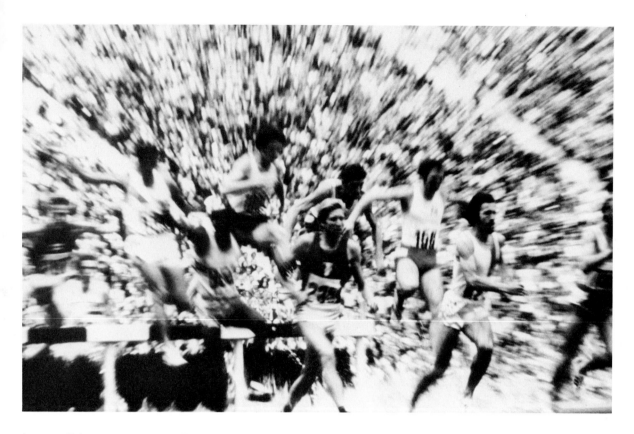

ing conditions: snow scenes, into-the-light shots, ice-rinks, or yachts on a bright blue sea against a bright blue sky.

Film

The slower the better. That said, it must be compatible with the speed of the lens and the available light. Kodachrome probably gives the best results. E6 films, such as Ektachrome, come in a variety of speeds and can be up-rated to 400, 800 or even 1600 ISO/ASA. This gives them good application in low light work. As for black and white, chromogenic films such as Ilford XP1, give fine grain results at a variety of speeds up to 1600.

Lenses

Most commonly used are the 35 mm, 50 mm, 85 mm, 135 mm, 300 mm, and 600 mm, but there are gaps in between that need to be covered. A 1.4X teleconverter converts the 600 mm lens into an 840 mm ultra-telephoto. A 16 mm fisheye is useful for one-off, unusual views. The 85 mm is particularly good for portraits. The faster the lenses are, the better, giving

the photographer greater flexibility – which can be critical in poor light.

Support

While long tele lenses are hand-holdable, extended use requires a support – either a tripod or a monopod. It is easier to follow the action through the lens with the camera on a monopod which makes it more flexible than a tripod. It is also very light and easily portable. Tripods are heavier and more difficult to carry around, but come into their own when very slow speeds are required. For added flexibility, the camera/lens combination need only be lightly attached to the tripod, allowing freer movement.

Motordrives

Offering automated film advance up to five frames per second, a motordrive is an essential tool. Winders are too slow at just two frames per second; the action can unfold so quickly so as to make the winder more of a hindrance than a help. Even with a drive, don't be duped into thinking that following the action and keeping the

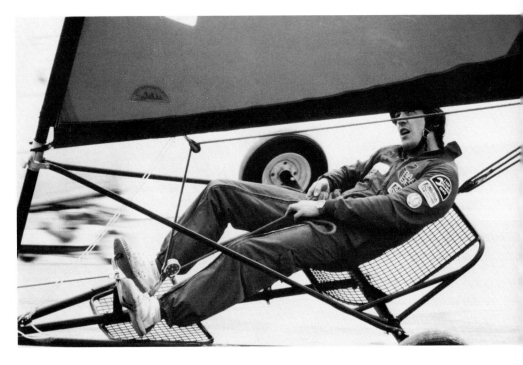

finger down on the button will suffice – it won't. The peak of the action might be precisely between frames. Shooting at 1/1000 second, with a five-frame-per-second drive, only 5/1000 of the action will have been exposed.

Most photographers prefer to shoot single frame advance, enabling them to retain full control over the precise shooting time. Drives with motorised rewind are useful, but only if the pressure is on and you need to re-load in a hurry – they use up important battery power.

Filters

Not essential, but two or three hardly take up any room in the camera bag. Coloured graduates can make a grey day bright – especially useful if overcast conditions are making the scene very drab. Cross-screen filters are handy for turning points of light into stars, especially indoors.

Remote control

A photographer can only be in one place at a time, but a remote control allows him to cover other angles. Whether it's in the back of the net at a football match (while the photographer is on the half-way line), or on the crown of the bend during a track race (while he himself is covering the finish

134 *Although this land yacht looks as if it is moving, it is, in fact, static. Steve Powell's efforts to get this picture are described fully in the text.*

line), it can give otherwise impossible shots.

There are three types of remote control. First, there is direct contact via an extension lead (impractical at a lot of events – but the most reliable); secondly infra-red; and, finally, radio control. There are restrictions in some countries concerning the use of the latter.

Accessories

A spare battery pack, screwdriver, tweezers, blower brush and tape all have their uses if something goes wrong. The camera may jam, and you might, if lucky, be able to clear it yourself – so it's as well to be prepared.

Bag

Soft, waterproof cordura or aluminium case? The bag is handy when you're on the move all day, while the case is useful for sitting on (or standing on) at football matches when the ground is wet.

10 Every Picture Tells a Story

The old adage that the camera cannot lie is one that every photographer takes with a rather large pinch of salt. Whilst it might not lie, it almost certainly never tells the whole truth. It can be argued that every picture *hides* a story. Sometimes the photographer has to cheat a little to add that *je ne sais quoi* to a photo. Sometimes he has to cheat just to get the desired image in the first place. This happens less often than might be supposed, but when it does arise it's the acid test of a photographer's ability to cope with pressure and come back with a picture when everything is against him.

Taking just three photos, Tony Duffy argues that there is a story behind every picture. Three key areas are highlighted: resourcefulness, persuasiveness and awareness. And, while they're not tools that are ready to hand in the equipment bag, they are essential ingredients in the sports photographer's armoury.

1 RESOURCEFULNESS

The picture of Robin Cousins executing a stag jump above the outline of the Rocky Mountains (*Fig. 135*) was specially commissioned by the *Radio Times*. They wanted to use Robin as their front cover for the 1980 Winter Olympics preview issue. He was the UK's only athlete with a realistic chance of a gold medal in the winter games and, like John Curry before him, was training in America. (He in fact trained with the same coach, Carlo Fassi, in Denver, Colorado.)

In November 1979, just three months before the Games started and just a month before the *Radio Times* deadline for laying out the cover, Duffy went to Denver with the mental image of Cousins leaping over the skyline of the nearby Rockies. He wanted to get away from the indoor ice rinks with their steel girders and fluorescent lights and get Cousins out into the open air at one of the numerous skating rinks which, he had been assured, were commonplace in the area.

On arrival in Denver, the weather was unseasonably mild and all the lakes for 50 miles around were the province of fishermen and ducks. There was not a single sliver of ice to be seen anywhere. Frantic phone calls to ski resorts up in Aspen, Jackson and Hole – more than 100 miles distant – elicited an equally negative response. The outdoor ice rinks in those areas didn't open until 1 December, two weeks too late for the deadline.

Having previously photographed Cousins in all the other locations that were needed for the feature and being on reasonably good terms with the skater whom he had known for many years, Duffy explained the problem and his suggested solution to it. To his eternal credit Cousins agreed, and that afternoon they bought a huge sheet of plexiglass from a D.I.Y store which they had been told would stand the force of a jumping elephant – let alone a man on skates.

The next morning was another warm sunny day and the anglers at a nearby lake were somewhat surprised to see a photographer armed with a massive sheet of plexiglass and a skater in a tight-fitting purple suit plus purple skateboots walk down to the edge of the lake and find a sandy area. They were even more surprised when the photographer lay flat on his stomach and

the skater, taking off his skate protectors, stepped onto the plexiglass and proceeded to do a standing stag jump.

Unfortunately the assistant in the D.I.Y. store had been somewhat optimistic, and the very first landing Cousins made sliced through the plexiglass like a knife through butter, dividing it into four neat segments. But Cousins continued shredding the plexiglass into fine grain particles with Duffy encouraging him to greater efforts. He was at the same time, trying desperately to keep ducks, anglers, rowing boats and other summery trappings from the bottom of the frame, whilst retaining the Rocky Mountain skyline in the background. All's well that ends well, for the shot made the cover and not a single soul wrote in to suggest that there was anything contrived about the picture.

Resourcefulness is much in demand in feature work. For coverage of an actual sports event it is less important but life being what it is, all the carefully planned and pre-conceived shots are liable to be pre-empted by the one set of circumstances that nobody catered for.

2 PERSUASIVENESS

Back in 1973 *The Sunday Times* sports editor decided to run a major series 'Sport and the Body'. The idea of the series was firstly to show how certain physical types gravitated to specific sports because of their physiques, and secondly to illustrate the demands made on them by those sports. Thus you have 25-stone shot putters and eight-stone marathon runners; soccer players who have very highly developed legs but no upper body strength

135 *Robin Cousins as he appeared on the cover of the* Radio Times. *The key elements are all there: the skater, dressed for competition, at full stretch; the deep, clear sky, giving a natural effect as opposed to the artificiality of the ice rink; the mountains, which emphasise the skater's height and indicate the location of the shot. On a practical level, there's also a space at the top for the magazine logo. What you don't see are all the behind the scene aggravations: plexiglass, fishermen, ducks and sailing boats.*

and motor racing drivers who have very highly developed arms and shoulders and weak lower bodies; basketball players who are 7 feet tall and jockeys who are 5 feet tall.

To launch the series with a big splash the editor wanted to do a nude photo of a couple who most closely represented the Ancient Greek ideal – immortalised in their sculptures – of the *perfect* sportsman and sportswoman. The first problem was to find them. The sportsman was not too much of a problem as the then British decathlon champion Peter Gabbett had recently retired and was quite amenable to the idea of posing in the nude in the famous discobolus statue position (*Fig. 136*).

The woman, however, was a major headache. The National Association of any athlete, swimmer or gymnast could be relied upon to veto the idea and, failing that, her manager, trainer, club or parents were likely to do so. The woman would have to be reasonably mature to fit the bill photographically and to be prepared to make up her own mind on the matter without undue influence from outside. Quite apart from physical characteristics the choice got narrower and narrower until we had been through All-Sport's complete list of current sportswomen and were still without a potential candidate. Somebody in the office then remembered that the 1964 British gymnastics champion, who had later married diving champion Brian Phelps, had featured in a cabaret act with Brian in a sort of acro-balancing style and, what's more, was still slim and attractive.

It was our only chance and having located her phone number, Duffy had the unenviable task of asking a total stranger, Monica Rutherford, to become the first woman to pose nude for the sports pages. He arranged to visit her one evening without telling her too much about the project and took down with him his own portfolio and some test shots that he had done with a dancer to show the sort of light-and-shade effect he was looking for, as opposed to the sensational glamour of the popular press. In spite of husband Brian's initial opposition, it was evident that Monica was intrigued by the project. Eventually she agreed, although had she known the furore

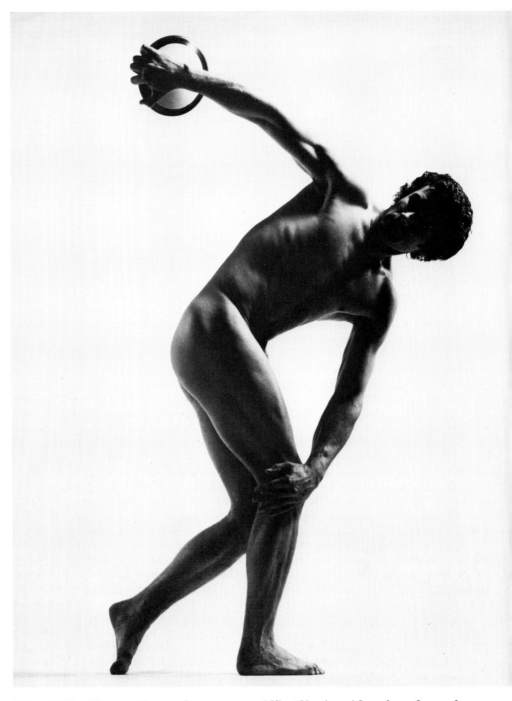

136 and **137** *These two photographs were designed to illustrate the ancient Greek athletic ideal for a* Sunday Times *features on sport and the body. Pictures were taken by Tony Duffy in the All-Sport studio.*
136 *Peter Gabbett, a former Olympic decathlete, was photographed in the classic discobolous pose.*

137 *'Unashamed Leap for an Image of Perfection'. Monica Rutherford was frozen in mid-air. In spite of the classicist approach, the picture caused a storm. If nothing else, it helped change attitudes, and the photographer's unmistakeably serious and tasteful approach to the subject was a key element in common sense winning the day.*

that would arise over the photos she might well have shown Duffy the door.

The studio session was arranged and the photos were taken. These were far from easy. The brief was to have a light-and-shade sort of effect, but also to capture the action. *The Sunday Times* sports editor then had to make the decision as to whether to approach his overall editor and risk having the project vetoed at the last moment. He agonised on this decision for a while and then locked the photos in his safe and, in the best traditions of Fleet Street journalism, decided to publish and be damned. The picture was used under the heading 'Unashamed leap for an image of perfection', and raised quite a few eyebrows, but the general consensus was that the whole subject was very tastefully done. That, however, wasn't the end of the story.

On the following Thursday, Duffy received a frantic phone call from Monica saying that a new P.E. teaching job which she had been assured was hers had suddenly been withdrawn – she felt sure because of the photo. Duffy, feeling extremely guilty about the whole thing, immediately rang *The Sunday Times* and to their credit they took up Monica's cause – perhaps sensing a scoop at the same time. The following Sunday they ran the picture on the front page of the main part of the newspaper under the headline 'Did this photo cost Monica her job?' They then gave all the details of the story and quotes from the school's governors from which it was quite obvious that they took exception to one of their teachers posing in the nude.

During the next few days the controversy raged. The photo was reproduced in most of the British newspapers and a vast number of Continental and American ones. Monica appeared on television under a huge blow-up of the photo and defended both her own decision, the photo itself and

138 *An awareness of potential is a key element for the creative photographer. This action-packed picture of Janet Pinneau was taken very much on the spur of the moment. But the chance element of bumping into an athlete in training is only half the story: it was awareness, knowledge of the sport, positional sense and a little bit of persuasion that make this picture come alive.*

the purpose for which it was taken. Such was the public censure of the Victorian attitudes of the school governors that they climbed down and gave Monica back the job. The story has a happy ending in that Monica settled down at the school and was immensely successful and happy in that post. As a matter of interest she is now the top gymnastics commentator for ITV and one of the country's leading coaches.

From the photographer's point of view perhaps the greatest asset in bringing this project to fruition was persuasiveness. There are many occasions when a photographer must persuade the subject to do something against the subject's wishes, even sometimes against his or her better judgement. Every time a photographer says 'just one more time, please', he is being persuasive. This quality is particularly apparent in Fleet Street photographers, especially those who specialise in getting the stars into the studio or to appear in fancy dress costume.

3 AWARENESS

A photographer needs to be totally aware at all times. Without this quality he isn't going to have a situation in which he can be resourceful or persuasive. Awareness is difficult to define in the context of the media and photography. Some photographers have an unerring instinct for a picture or a feature and, no sooner have they thought of the idea or seen the pictorial possibilities, than their mind automatically catalogues the various markets in which it can be sold. Awareness is partly a matter of keeping your eyes very much open to pictorial possibilities. One famous photographer remarked 'photography has taught me to see', and he might have added a rider 'and to be aware.'

One example of awareness was whilst Duffy was in California completing a feature on women in sport for an American publisher. He was walking along the beach near Venice in Los Angeles when he noticed a sort of hollow caused by the sea's action. This gave a worm's eye view of the beach as the hollow was about 6 feet deep. As sports photographers very often work from moats and since the low angle in many sports adds drama and punch to a picture, this particular location registered

in Duffy's subconscious. He continued his stroll along the beach until he came upon a girl baseball player throwing to her trainer. They both had huge catching gloves on their left hand and Duffy, who is interested in javelin throwing, noticed the incredibly fast arm and easy throwing action of the girl. He watched for a few minutes and, during a break in training, asked her if she had ever tried throwing a javelin.

In the course of their quick conversation it transpired that the girl was a star softball player on a softball scholarship to U.C.L.A. (University of California and Los Angeles) and a member of the All-American softball team – softball is the women's version of baseball. She explained that her position was catcher, (a sort of wicketkeeper) as opposed to being a pitcher. Realising that he was on a tight schedule and that it would be impossible to set up a photo session in the next few days, Duffy cajoled her into doing some photos there and then.

He retraced his steps with her until he found the hollow he had noticed and, positioning himself in the hollow, he persuaded a passer-by to throw the ball at her so she could dive for it whilst he got the worm's eye view of her in mid-air (*Fig. 138*). The levelling off effect of the sands from this angle made it look like the run up of a baseball diamond and, of course, the flat out dive the girl was doing did her no harm as she landed in soft sand. He only had a Nikon FE with a 50 mm lens with him and half a roll of film, but he realised that the shot looked spectacular through the lens. The whole thing took 20 minutes from start to finish and, in that time, the most difficult thing was to convince the girl that he was not some kind of freak, but that he really needed her for the feature!

His awareness was on different levels. Firstly, the awareness of the location which came to the forefront of his mind just when it was needed. Secondly, the awareness of sports which allowed him to realise without knowing who she was that the girl was a top-class athlete. Thirdly, the awareness as to the picture potential of her doing a flying catch. Lastly, the awareness that the late afternoon light was ideal for the picture.

11 Style-Don't Cramp It

Critics who argue that a sports picture is just a sports picture and nothing more nor less are not only missing the point; they are also denigrating the scope and variety of approaches that can be seen within the work of different sports photographers. A sports photograph can be just as much a work of art as any other photograph, although it does seem to be that much more difficult for sports specialists to achieve worldwide recognition outside the sporting sphere.

At one extreme, the works of a Helmut Newton or an Ansell Adams are instantly recognisable. Others, less famous, might not be so easily identifiable, but each photographer has his own style, his own way of taking pictures. Just as you can recognise the work of different painters, poets or novelists, so many photographs carry the invisible trademark of the photographer.

One thing is certain. It's not a question of one technique or style being right and all the others wrong. Each photographer is making a statement and each, in its own way, is equally valid. He is putting his own interpretation on the subject. One particular style might be the current fashion, but within a short space of time it can equally become unfashionable. But a style that is popular today, might not still be so tomorrow and the success of a photographer can be measured by whether or not he is remembered in years to come to future generations. It is interesting to speculate whether the individual photographer can actually alter his style to any great extent. If he does try to do so, he may be in danger of losing his way artistically.

Photographers who are unsure of their style, or who feel that because they have not received full acclaim they must be on the wrong track, may be tempted to copy the style of someone who is in vogue. This is a great mistake. Every photographer is influenced by other photos (such influences are very important in the development of anyone working in a creative medium), but while it is one thing to obtain ideas for your own pictures from another photographer's treatment of the same subject, it is a different thing altogether to copy their work.

In many respects a photographer's style reflects his attitude towards the subjects he is photographing. To explain this, let's look at the varied approaches of All-Sport's trio of Tony Duffy, Adrian Murrell and Steve Powell.

TONY DUFFY: LINE, EXTENSION, FORM

I would best describe my style in three words: *line*, *extension* and *form*.

To me, sport is so fascinating, dramatic and beautiful that I only need to capture the *essence* of what is happening to obtain dramatic photos. I seldom try to add anything to a sports picture in the way of photographic gimmickry or technique because, in so doing, I tend to lose the concentration which is essential to take the dramatic – but basically simple – shot that I admire so much.

Sport is all about the body – the greatest machine ever invented. The body has fascinated artists and sculptors for thousands of years and in today's over-civilised and generally unfit society there is a special fas-

cination in watching the elite corps of the world's great sportsmen and women: whether it's pushing their bodies to the limit of human achievement or exhibiting incredible skill with ball or racquet. Just as the first person to climb Everest or the first man on the moon pushes forward and extends the limits of human achievement, so too does the first man to run a four-minute mile or the first woman to throw the javelin 75 metres.

Given the basic interest in the subject, the first essential is to view what is happening and break it down into its component parts. The best example I can give is this: watch the start of a 100 metres sprint race; the starter's pistol fires and the runners surge forward in a blur of movement. Now watch this very carefully and run through in your mind in slow motion what you have just seen. Then take just one runner and go through it again. See the body come up into a 45-degree position from the ground, straight as an arrow as the sprinter drives off from the starting block. See the synchronisation and perfect balance of driving leg and opposite driving arm. See the sheer determination in the facial expression and also the muscles and sinews at full stretch.

This is what I mean by watching the action and trying to isolate specific moments. The same philosophy applies to the start of a horse race or even a swimming race. Don't forget, however, that it is not limited to the start; what is intrinsic in the start takes place throughout an event – very often just as dramatically at the finish.

Having chosen a subject that looks promising, if I then analyse my thought processes I ask myself whether it has line, extension and form.

Line is difficult to define, but instantly recognisable. Any diver or gymnast will immediately tell you what line is. In a nutshell, it is a pleasing symmetry, a graceful and harmonious movement. Very few of the world's great divers or gymnasts have been short, stocky, plump people because, however hard they tried, they would not achieve a good line.

Extension is a vital ingredient in line. If a diver has his arms stretched out to the limit his toes pointed and his back arched, he is at full extension.

Extension adds drama and commitment to your picture. It is the difference between a goalkeeper falling on a ball to one side of him and diving in a full-blooded way to catch it in mid-air. It is the difference between a half-hearted tackle and an all-out challenge. A photo of a runner with one leg driving forward and the knee at its maximum uplift, arms pumping, feet off the ground, has extension. But the same runner, at the moment when one leg passes the other, has both legs almost in a straight line: one foot is on the ground, his arms are crossing past his body, and the whole picture lacks extension. A tennis player, serving with both feet off the ground as he strikes the ball, has extension, but the same person doing a slow spin second serve in a static position has not.

Form This primarily applies to women competitors who have grace and beauty, but it is by no means confined to them. Many male sportsmen have form in the sense that they have balance. A photo of a footballer with the ball at his feet has far more form than a photo without the ball. The same applies in many cases with tennis and cricket, or any ball sports for that matter. Form is as close as you can come, in sporting terms, to composition. It often means the subject filling the frame and being pin sharp. It means a clean, uncluttered background or a fuzzed-out crowd backdrop. Either way, if a photo has form it doesn't detract from the subject. It also enforces the statement that the photographer is trying to make about the subject.

A photo that has line, extension and form is the accompanying shot of top sprinter Donna Hartley (*Fig. 143*) who, when the photo was taken, was the British sport's Golden Girl. This photo illustrates my earlier comments about the start of an event. I invited Donna to the studio specially to recreate the start position mentioned above without any distractions and encumbrance. The resulting picture shows line in the 45-degree, arrow-like angle of drive off the starting block; it shows extension with the driving leg pumping up, the arms counterpoised and

139 *Tony Duffy argues that a shot of a footballer with a ball has much more form than a player without the ball. Steve Powell exposed this picture of Argentina's Maradona.*

140 *This picture of Donna Hartley captures her during a sprint start, well away from the athletics track. Shooting her against a plain background in the studio concentrates the viewer's attention totally on the athlete.*

the foot just leaving the ground; finally, it shows form in the general pleasing aspect of the athlete and the overall balance and impact.

ADRIAN MURRELL: SHAPES

My background is very much one that has been influenced by news reportage photographers. I've been affected by Cartier Bresson, Ansell Adams and Don McCullin. Indeed, my approach is not the obvious approach to sports photography. Many sports photographers are peak-of-the-action photographers. Capturing one of the world's fastest bowlers in full flight is one thing, but I get more pleasure in watching for the expression of the bowler just after the delivery. It's an after-the-incident or after-the-peak-of-the-action

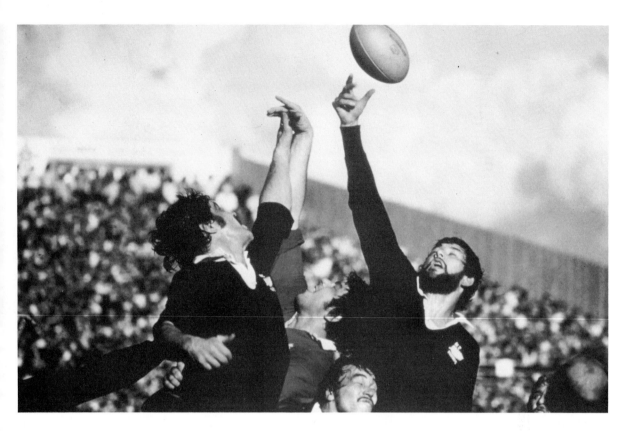

shot. I shoot with a motordrive on single frame advance to get both shots – height of the action and then the emotion afterwards: whether it's triumph and jubilation or failure and dejection, the expression enhances the photo.

Shape and form are also very important – and here the facial expression has an important role to play. I am continually aware of shapes. For example, in a cricket match with a fast bowler, the slip fielders cluster in a pattern to the batsman's offside, forming a natural shape. Another position I like to shoot from in cricket is square leg. Particularly with a slow bowler, the fielders huddle close around the bat, forming an attractive picture: a batsman swinging at the ball, with the fielder's response, adds to the scene. The ball isn't a critical element, surprising though that may seem. But if it is there, it's an added bonus.

To work with the shapes, and to bring them out to the fullest degree, I'm very conscious of the background. Advertising banners destroy the shape. Choosing a high background and, therefore, having

141 *Adrian Murrell looks for shapes in sport. This line-out was taken during a British Lions' tour of New Zealand. The leaping figures give a symmetrical appearance, the impact of which is heightened by the ball.*

the grass as the backdrop eliminates this problem. I would rather move away from a safe position (where action shots are guaranteed) with a poor background and take a chance with a risky angle with the correct backdrop to complement the shapes. To me the shape, with the right background, is the most important aspect of my photography. Crowds can enhance the subject.

When shooting rugby, I concentrate on the line-outs and scrums. I follow the action from the touchline and when the first line-out in a game takes place, I will watch it without taking a shot. I'll see who's receiving the ball and check out the angles. Then, with the next line-out, I'll position myself accordingly. I like to have the creative control over the final image – which is possible with line-outs (*Fig. 141*).

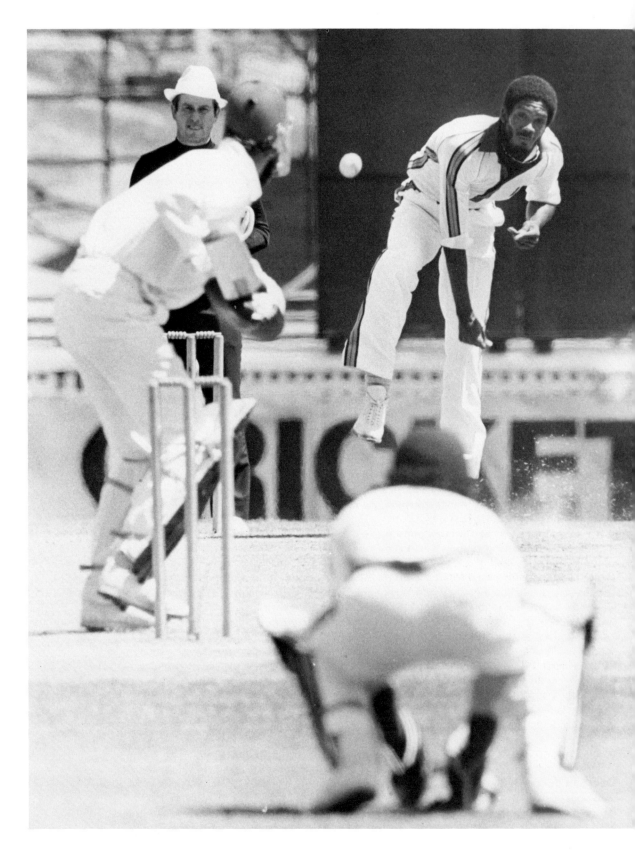

Simply following the action with no such control, you're leaving much more to chance.

I like to build up a theme and to take any pictures particularly associated with a specific sport. Hence during the Indian cricket tour I liked to get away from the grounds and take shots of the kids in the streets and the cricket bat factories. While covering a West Indian rebel cricket tour of South Africa, I was equally happy shooting in the underprivileged black township of Soweto and focusing on the crowds as I was working at an upper class all-white club, the Wanderers. During one specific job shooting fishing, I was happier to take some close-up shots of different types of maggots than I was taking the more straightforward pictures of fishing action.

Overall, I find that creative control allows me to record pictures that possess shape and form: with a complementary background, such aspects as facial expresion and, in ball sports, the presence of the ball, add to the image.

STEVE POWELL: POWER

I'm the first to admit that I'm not the most knowledgeable of sports fans. I'm not too knowledgeable about statistics, or a particular team's form or anything like that. That's not the attraction for me in sport. But I know *about* sport. What attracts me to sports photography is the sheer variety of the subject. It encompasses just about every element of achievement and emotion that can be captured in a single action. I'd say that it's the ultimate human endeavour to stretch men and women to their limits. And that's not just a physical effort. In my photographs, I'm trying to say something about the inner man, the man who has really achieved something. Bjorn Borg, for example, totally dominated the tennis scene for several years, and it was a challenge to try and capture the inner person in him.

If you take the diffuse elements that sport generates – whether it's danger, fear, excitement, anger, hatred, elation, despair, frustration, colour, beauty – they are all witness to the fact that the participants are at their best, pushing themselves to the limits of human experience. Just to watch it and then try and catch it on film is a tremendous experience. The various elements within sport add up to one key ingredient – *power*.

Daley Thompson, breaking the world decathlon record in Athens (*see Fig. 48 on p. 54*), is one example. The picture of him just after the final event, the 1500 metres, summed it all up. His defeated opponents were sprawled over the track, while Daley, although tired, was still on his feet. The photo that resulted not only said a lot about him, it also highlighted the intrinsic power within a sport. Borg's power is of a different type – but, nevertheless, it is still there. This power doesn't, of course, just exist within a few elite individuals. It can be illustrated in teams, although I personally prefer to record it in an individual.

Taking this a step further,there is power in a sport as a whole. The shot I took of the powerboat race start (*see Fig. 6 on p. 13*) typifies this. Taken from a helicopter, with a distorting wide angle exaggerating the ocean's breadth, the picture captures the magnificence of that particular sport. And the power is there, too. It's in the machines roaring across the ocean, carving out their own paths, leaving obvious tracks in their wake.

Horses, too, have personality and power. I found it a stimulating exercise to do a shoot of top racehorse, Shergar (*Fig. 144*), taken a year or so before he was sadly kidnapped. He projected power and a unique personality, but trying to portray that was very difficult. You can make a person smile or look coldly, but how do you get a horse to create an impression?

I see myself essentially as a communicator. I'm not an artist. In photographing top sportsmen and women, I am watching them at their peak, and trying to capture that elite, intrinsic worth on film. The end product, the photo, is my attempt to communicate what I see.

142 *Another picture that shows shapes. Michael Holding lets fly at Mike Brearley, during a one-day international between England and the West Indies in Sydney, Australia. The picture gives a vivid impression of what it's like to face one of the world's fastest bowlers.*

I enjoy the challenge thrown up by environmental problems. I enjoy overcoming such obstacles, as extreme cold or a particularly difficult shoot. Underwater photography has recently presented me with a new dimension. The Winter Olympics in Lake Placid was a shoot that provided enormous problems, mostly associated with the cold, but I was communicating, which is my role. I'm something of a purist in that I only enjoy sport at its highest level; I like to see top sportsmen and women performing at the peak of their ability.

YOUR STYLE

The three styles evident in the three photographers indicates just how varied the approach can be. All three are, in their own right, equally valid. No doubt the sports photographer is particularly influenced by those sports he enjoys shooting most. Murrell's interest in the shapes, form and expression of cricketers just after the moment of peak action reflects his own passion for cricket: that long, intricate game lasting five days which might lack the intense quick passion of an FA Cup Final, but makes up for it in its intellectual complexity.

While the photographers have different approaches, there are also some striking similarities: we can all recognise a good picture when we see one and it's inevitable that there is some overlapping of style. The most important thing is to let your own individual style evolve.

143 and **144** *Steve Powell emphasises power in sports, waiting to be captured. Here are two studies of sporting personalities whose existence exudes power.*
143 *Larry Holmes, a boxing world heavyweight champion, is photographed with his eyes shut, the beads of sweat flying off him after an extensive work-out.*

144 *Shergar, one of the finest racehorses of all time, in his stables. Trying to capture Shergar's innate power wasn't easy.*

12 Competitions

TECHNICAL MERIT V ARTISTIC IMPRESSION

Are competitions worth entering? Do they have any real significance? Are they just a waste of valuable time that could be better spent earning money? These are questions that most photographers will ask themselves at one time or another, particularly if they have already entered quite a few competitions, but have never come up trumps. That must include most people. Out of the thousands who enter photographic competitions every year, only a very small percentage will end up among the ranks of winners or 'highly commended' shots.

The judgement of a photograph is a very personal thing which can be influenced by the personality, likes and dislikes, opinions and attitudes of the judge. Just as in skating, diving and gymnastics the marks put up by the expert panel of judges can differ considerably, so to can a number of judges differ on their assessment of photography.

Tony Duffy has seen both sides of a competition. Not only has he entered and won them, but he has also been in the position of judging. The experience was enlightening. He had been invited to be one of three judges of a sports photography competition held in Dubai. There were five categories of sports to be judged. He had viewed all the photographs and made notes of the ones he liked best. Comparing notes afterwards with the second judge, a famous feature photographer from *Paris Match*, he was pleasantly surprised to find that they had chosen the same photographs in each category, although the

ranking orders differed. The third judge was the chairman of the local photographic club and a very wealthy architect. Photography was his abiding passion and it seemed that his whole house had been turned over to darkrooms, studios and workshops. His choice of photos was totally different to that of the two practising professional photographers. He had chosen three alternative photographs in every one of the five categories. During the subsequent discussions it became clear that their viewpoints were totally different and, in the end, the chairman of the judges had to put each photograph to the vote and judge the competition on a sort of majority votes principal.

Just as in skating the judges award two marks, one for artistic impression and one for technical merit, so too in judging sports photography competitions technical opinion seems to be divided. The judges with the pure photography background tend to look for print quality and presentation, whereas those judges chosen from practising photographers and photo editors tend to look more for subject matter and content. There is what one might call the conflict between technical merit and artistic impression.

This difference of opinion seems to occur in the judging of most competitions, both in this country and abroad. Any photographer proposing to enter a sports photo competition should, therefore, be aware of it and endeavour to appeal to both types of judge.

Taking this a stage further, the photographer, with a bit of common sense, can turn this apparent difficulty to advantage

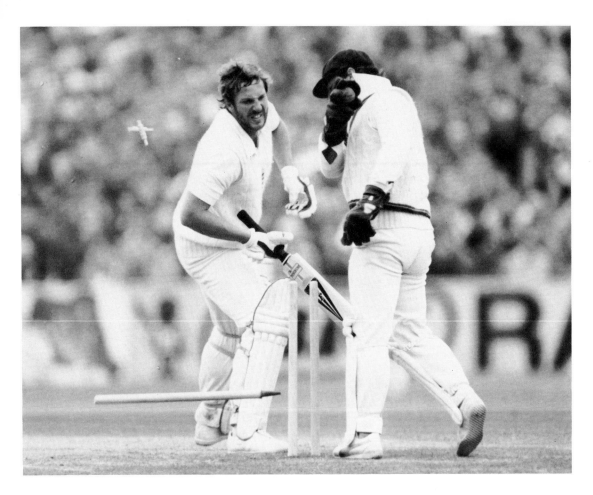

145 *Australian wicket-keeper, Rodney Marsh, attempts to stump Ian Botham during the fifth Test at Manchester in 1981. This shot won Adrian Murrell the Ilford Sports Photograph of the Year award – just one of many awards that the All-Sport photographers have won over the years.*

and exploit it to its full to increase his chances of winning. There are pictures where the two contrasting elements can be brought together: good, sound technical merit allowing (but not infringing) artistic quality.

Presentation

Unless the subject matter is sensational, don't bother to enter a photo if the negative or transparency is incorrectly exposed or worse still, scratched or dirty. If prints are sent in, they must be of the very best quality, presented to the best effect. Presentation is very important: mounting and borders shouldn't be too ostentatious or they will detract from the picture, but the print should look smart. Pay great attention to cropping. One of the most frequent criticisms of work submitted is poor or total lack of cropping of pictures. Make a point of reading the rules. It is remarkable how many entries are too large or too small or otherwise disregard the instructions laid down in the competition.

What photos should you enter? Where the competition is for a single photo, go for the shot with maximum impact. If it requires a portfolio, you can be more adventurous. A portfolio of ten pictures is not uncommon and, indeed, is the format for all the Sports Council's national and regional sports photography competitions. In these cases the judges are looking for a mixture. If you can enter ten different sports, that is ideal, but if you can enter only one sport that need not necessarily discount you – providing there is a variety

of angles and subjects. Try to enter some photos which have tremendous impact and others which have an artistic angle – either in terms of pure photographic technique or unusual treatment of the subject. Emphasise the range of your work in every possible way. Long lenses and short lenses, high angles and low angles, big international events and the small club or fun event, young and old people playing sport as well as the international stars – try to show your *versatility* and *mastery* of the subject.

In general it is advisable to steer clear of the standard angles and stock-type pictures, but a word of warning. Say you have collected eight out of your ten pictures and are happy with the portfolio so far. It might be better to put in two very good stock photos of different sports to complete the ten rather than a high risk shot which some people like but others won't like at all.

Many competitions require captions with photographs detailing information as to the date and event. Give careful thought to a concise caption. This can make a difference and will certainly look much better if your photograph is displayed in an exhibition. It's not always easy, and it pays to show the print to as many people as possible and ask them to comment on the captions. At All-Sport we enter our portfolios of ten for the British Competitions at the end of the year, we have great fun on Christmas Eve laying out the photographers' portfolios and, with imaginations well lubricated with seasonal spirit, encourage all the staff to chip in with ideas. Some of the very best captions have come from these impromptu sessions.

In those competitions which require just one single photo it is often those photos which were purely a matter of luck that succeed; if the photographer happened to be in the right spot or if there is a humorous angle to the photo. Pictures of horses falling, or cars and powerboats somersaulting through the air are frequently winners of this type of competition. Duffy's photo of the horse falling at Badminton has been widely used and was, in fact, the only sports photo in the *Time Life Books* photography year annual for 1977. On the humorous side, the shot of the streaker at Twickenham (*Fig. 149 on p. 158*) went around the world. Murrell's photo of the mud-covered British Lions Rugby Player in New Zealand (*Fig. 151 on p. 160*) received tremendous publicity when it was first released. These pictures both appealed to people's sense of humour and reached an audience far wider than the sports fan.

WINNING COMPETITIONS

When a staff photographer wins an award, the photos are usually spread across pages and the award is trumpeted in banner headlines. It makes sense from a commercial point of view and it helps to sell papers. We have always been amazed how reluctant those same papers are to publicise anybody else's awards. The lesson for the freelance or agency photographer is that it is up to him to publicise his own achievements – immodest though this may seem. If you don't do it, nobody will do it for you. It can be done tastefully and in a way which will not embarrass either you or clients. We have found the best way is to have prints made of the winning photo and circulated to all our clients and to the various media and magazines. If these can be incorporated into a calender, visiting card or Christmas card, then so much the better.

Having looked at competitions, we still come back to the question – are they worth entering? Well, winning a competition doesn't make you any better as a photographer. Similarly, not getting in amongst the winners doesn't make you any worse. But, a competition victory can do for you in one week what it might otherwise take a year or two's hard graft to achieve – it will give you recognition (on an international scale with the major events) and acclaim. It will get your name known. It will help to pluck your name out of the list of 'also rans'. It's certainly not going to harm business!

On a wider scale than the purely personal consideration, competitions have an important role to play. In an industry where dynamic images are crucial, it is only fitting that there is some recognition for the best of these. It stimulates interest in the sports photography industry. Not only is this good for business, but it highlights the very best in sports pictures.

13 The Test of Time

The fundamental question in photography is *what makes a good picture?* Every photographer must have asked himself this question. Every picture editor subconsciously supplies the answer each time he selects one picture from a batch for publication. It's a simple question but the answer can be very difficult. It is easier to recognise class and quality than to account for it. But if you lay out a number of photos, the award-winning shot will always stand out. Why should this be so? Well, as we will see, impact and universal appeal are twin giants in good photos. A third element is originality. One way to answer the question is to look at some top sports pictures and see what attributes they have in common.

IMPACT

Possibly the most important ingredient for an all time great picture is *impact*. In many cases this means having a good, clear image on the photo; one which is instantly recognisable for what it is and not something intricate and complicated – no matter how artistic that might be.

Consider the World Press awards for the last three Olympic years. In 1972 there was a classic shot of a gargantuan super-heavyweight wrestler tumbling down on top of a seemingly minute opponent. The picture had so much impact it made you gasp, if only because of the unreal size and ugliness of the contestant.

The 1976 Olympic year provided the classic shot of the weight lifter jumping for joy. He had completed his lift to the satisfaction of the judges and won the gold medal – whereupon he dropped the weight and jumped in delight. The photographer caught him in mid-air just as the huge weight had bounced back off the platform at a crazy angle. Result? Both he and the weights were airborne and he was shouting for joy. He was also a huge man.

The 1980 World Press Award, won by Joe Marquette of Associated Press featured Sebastian Coe shouting in triumph as he won the 1500 metres Olympic final from arch rival Steve Ovett. Again a head-on picture; Coe, filling the frame and yelling excitedly in his victory, has tremendous impact. As well as the features in the picture, there were off-camera ingredients. The Coe-Ovett rivalry (with first blood to Ovett in the 800 metres) put added pressure on Coe for this race. And, of course, the 1500 metres is the blue riband event of the whole games.

Each of these pictures registers an extremely powerful image. They shocked – and continue to shock – the viewer with the boldness of their statement. They could not be overlooked or ignored.

Does a photo only have impact if taken in an Olympic final or of a famous person? No. Both the 1972 and 1976 subjects (the weight-lifter and the wrestler) were totally unknown – even to most sports photographers. The photographs would have been just as effective if they had been taken at their local club rather than the Olympic final. But whilst it is not essential, 'impact' is helped enormously if the photo *is* of an international figure taken at an international event.

Duffy's photo of Bob Beaman's amazing long jump at the 1968 Olympics (*Fig. 147*) would be an interesting picture had it not

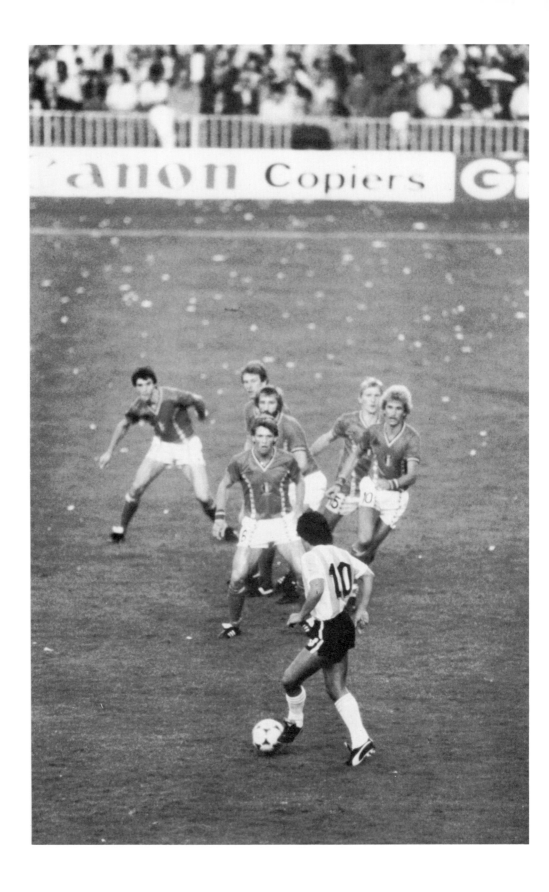

been the particular jump that took Beaman into history. However, everyone looking at the picture asks: 'is that *The* great long jump?' and, being told that it is, they look at the picture with renewed interest. Likewise, a shot of Jesse Owens starting in the 100 metres sprint at the 1936 Olympics (*Fig. 148*) would have been a great picture in its own right, but, being of the black superman of the Hitler Olympics gave a fine picture even more impact. Just to rub this point in, it has to be admitted that the famous shot of Henry Cooper dumping Cassius Clay (later Muhammed Ali) onto the seat of his pants owes more to the fact that it was his notorious opponent at the receiving end of the left hook than to any intrinsic greatness in the picture.

Press awards, in particular, are inclined to favour impact pictures, because this is bread and butter to the national newspaper industry and, indeed, to the magazine industry. Some very fine photos have won critical acclaim with subtle juxtaposition of colours or the interplay of light and shade, form and symmetry. These can always be admired as a work of art or as a clever technical exercise, but, unless the picture has impact, it is not likely to stand the test of time in the real sense of the word and enter the all-time greats list.

One way to create impact is to meet it head on. Look at Powell's photo of the horses racing on the snow and ice of St Moritz Lake (*colour plate 5*). They are coming right at you. You are there, part of the scene. You can almost hear the thunder of their hooves. Likewise Marquette's photo of Coe, which also has the subject leaping straight out of the picture at the viewer.

146 *Impact is a key element in sports pictures. Argentina's brilliant striker, Maradona, can find no way through this gaggle of Belgian defenders during the 1982 World Cup finals in Spain. This shot, taken by Steve Powell on a 600mm f4 lens, sums up Maradona's dilemma, where skill was crowded out by mass defences. This was typical of the finals, and Maradona was eventually sent off in Argentina's last match before they were eliminated. Even from a high position in the crowd, good pictures can still be obtained.*

Either of these two shots taken from the side, with subject going across rather than out of the photo, would have lost all their impact. Impact puts the viewer in the thick of the action and makes him feel that he is actually there. There is nothing subtle or suggestive about it. It is a bold, uncompromising statement.

UNIVERSAL APPEAL

This is the second quality which is necessary for a good picture to become a great one and to stand the test of time. There is no distinction betweeen the basic human emotions portrayed by the participants – whether it is a poor cricketer in the suburbs of Karachi or England's richest on the playing fields of Eton. A picture knows no language barriers; when a sports photo accurately captures or reflects these basic feelings it has universal appeal. Every participant runs the same gamut of emotions: total effort, determination and concentration while competing; joy in victory and sorrow in defeat; nervous tension before the event and good sportsmanship after. These are the fundamental ingredients of sport whatever it is and wherever it is played.

Sometimes these basic human emotions are taken to absurd extremes and can result in photos which become a parody of the subject. Photos of footballers screaming in mock agony after being fouled and acting to the referee in the hope of gaining a penalty, fall into this category. Likewise, on the same subject, are those photos of referees giving players marching orders or lectures. Many such shots come to mind from the football press in the last 20 years and some of them are classics.

A touch of comedy is never a bad thing and, if it's ribald at the same time, then so much the better. The photo of the streaker at Twickenham (*Fig. 149*) is essentially humorous. The nude man is the focal point for all the other ingredients. The expressions on the faces of the two policemen and the club secretary hurrying up with his raincoat (looking shocked that such a thing can happen at his beloved rugby ground) all add universal appeal to the photo. It has essential *impact* because it was possibly the first of the streaker photos which were the craze in the early 'seven-

147 *and* **148** *A key element in successful sports photographs is significance.*

147 *Tony Duffy's shot of Bob Beaman's long jump is a good picture in its own right. However, the significance – that Beaman devastated the world long-jump record with a superhuman leap – gives it added impact.*

148 *Similarly, the shot of Jesse Owens in 1936 has only lasted as a memorable picture because of the background significance to Hitler's Berlin Olympics. Owens was the 100 metres, 200 metres and long-jump champion.*

ties. Certainly the black and white versions of this picture made front pages throughout the world.

In some respects the skateboarder photo (*Fig. 150*) could be included in the test of time category. The universality of its appeal reflects man's rather pathetic attempts to achieve something difficult, his determination to succeed, and the mess he so often makes of his efforts – rather like the fat man falling on a banana skin.

It's remarkable how many sports photos

show the participant with an interesting face. Just as the skateboard boy's tongue is sticking out and his mouth is wide open in concentration, so too the faces on all the other great pictures mentioned are absorbing studies in themselves. The face is a fascinating thing to look at – witness how many portraits appear on the covers of magazines.

Also falling into this category of universality of appeal and a slight sense of the ridiculous is Adrian Murrell's picture of the mud-covered rugby player taken on the New Zealand tour (*Fig. 151*). The impact is there and the appeal of the picture is the same to young and old, men or women, and Easterner or Westerner.

ORIGINALITY
Given that impact and universality are two major requirements, an additional one is *originality*. This can be an original view in terms of an unusual angle which helps the viewer see something in a new light, or it could equally be a new and original technique of photography making an unusual visual statement.

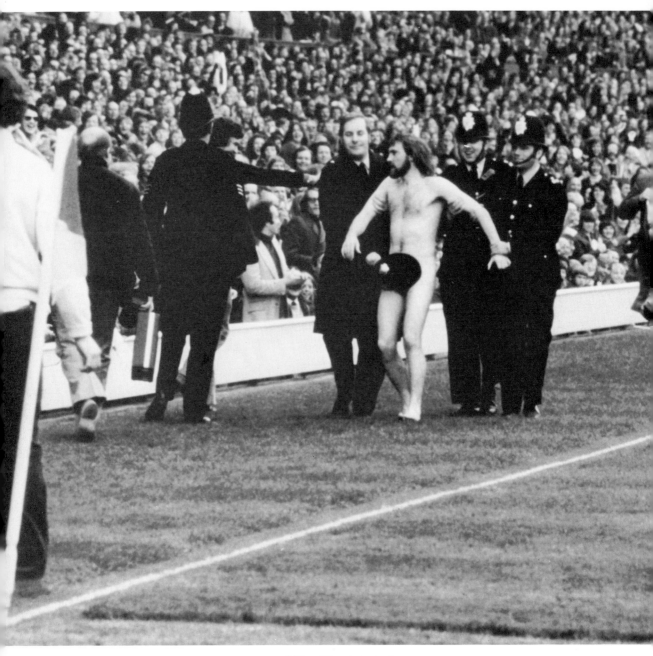

149 *The original Twickenham streaker. This picture was very successful because it was taken right at the beginning of the streaker era. It occurred at half-time when many of the photographers had gone in for a cup of tea. However, Tony Duffy remained and got the incident in colour. Duffy has only been to Twickenham twice in his career. The first time, this picture resulted, while on the second occasion Erica Rowe made her topless dash across the pitch. Did somebody mention the word collusion?*

150 *What happened next? Many sports pictures score because of the sense of impending disaster. Tony Duffy had been shooting a feature on skateboarding and had been working with another child. While on the session, in the corner of his eye he kept seeing this particular lad getting higher and higher in his jumps. Eventually, Duffy whipped round to this lad and took a shot through a 16mm lens (it happened to be on the camera at the time) and got this picture. It became one of the best-selling photographs of the period and was also published on the cover of* The Sunday Times *magazine.*

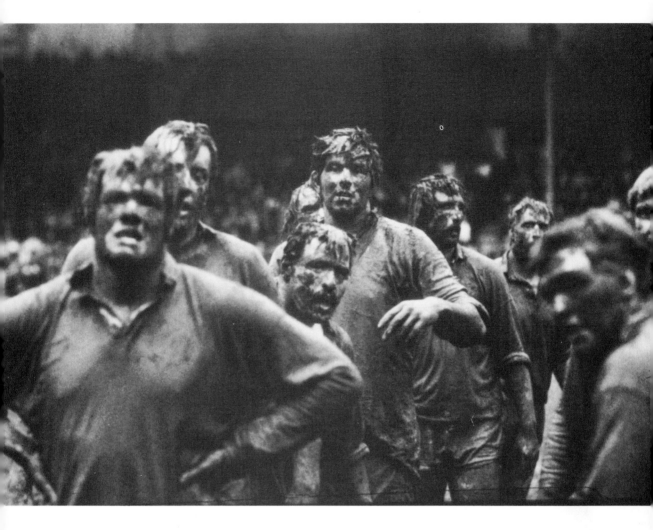

151 *Rugby players or marsh-men? Murrell's picture of the British Lions on tour in New Zealand in 1977 shows how the pitch has swallowed up both sides to make them all look the same. An ordinary line-up is turned into a memorable shot by the vast quantities of mud.*

Originality in terms of technique will only enable a picture to stand the test of time if it has impact and universal appeal as well. Technique alone will not carry a picture through. The first photographers to produce zoom lens explosion shots, silhouette pictures or impression photos received critical acclaim in the photographic world, but the pictures, although using an original technique, often lacked the other two qualities necessary and consequently fall short of being all-time greats.

Originality of the subject or the angle from which the subject is shot is another matter. The photos already mentioned of the weightlifter and the wrestler benefited from being incongruous situations. Subsequent pictures of similar themes might have been even better technically but lacked the originality of the first.

Incidentally, the requirements for the test of time in sports pictures apply equally to general press photos. The striking war pictures of the Saigon informant's execution and the little Vietnam girl injured in a napalm bomb attack had universality of appeal – dealing with death and disfigurement. They also had impact and were strong images of shocking events.

14 A.D. 2001

What will life be like for the sports photographer in the year A.D. 2001? Indeed, will there still be such a thing as a sports photographer at the dawn of the twenty-first century? And, if the species does survive, how will he be operating? what sort of equipment will he be using? On the basis of current trends, educated guesswork and a lot of speculation, here's a picture of his life in the year A.D. 2001.

SPORT

Sport is now accepted as a global war substitute. Governments spend millions of dollars preparing sports teams and individual stars for the showpiece international tournaments. The most popular team game in the world is American football. The Europeans adopted the sport in the late 1980s and the Eastern Block soon followed. The showdown is between the American and Russian teams with a worldwide TV audience of billions.

Athletics is now totally professional. The Olympic champions are the highest paid sportsmen and women in the world. The most successful country overall at the last Olympic Games was China which dominated the gymnastics, diving, volleyball, judo and archery events. The Eastern Europeans continue to dominate the women's events where the standards are now higher than the men's were in the 1970s.

Many sports failed to survive the turn of the century. Soccer was the main casualty in the spread of American football. This was partly due to the greed and short-sightedness of its players and administrators, but partly due to the violence of the fans. Eventually the government had to outlaw football as happened in the Middle Ages, due to frequent urban riots between battling fans.

Tennis was another popular sport in the early 'eighties, but the public swiftly became disenchanted with its prima donna stars. The turning point is believed to have been when McTavish, on his way to his sixth Wimbledon title, attacked an 80-year-old linesman with his steel-tipped racket and blinded him with a blow to the head. McTavish's lawyers successfully argued that the linesman had been blind before the game started and he was let off with a caution. A representative from the Tennis Association claimed not to have seen the incident.

The media pay vast sums of money to cover the major sports events and every home has its cable TV with 24-hour sports channels. Newspapers and magazines have been totally replaced by video except for a few artwork magazines on sale to a steadily decreasing readership. But the multi-millionaire sportstars have teams of agents representing them and vast sums are demanded and received for TV interviews, endorsement performances and appearance fees.

PHOTOGRAPHY

Oddly enough, it wasn't until 1989 that Gypsy Rosa Lee's crystal ball was replaced by an electronic time warp console. Technical developments in photography reached the crossroads in the mid-'eighties. Since the earlier part of the twentieth century, photographers, strange as it may seem, had got by perfectly happily with

silver-based emulsions. Even so, they used to lambast the film makers with accusations using such odd words as 'golfball grain' 'speed' and 'greencast' films. But, like their grandfathers before them, they used to retreat into darkened rooms and put their films into special canisters into which they would pour a variety of brews. Just like witchcraft.

These silver-based films continued to be

153 (ABOVE) *The Sony Mavica, announced for the first time in the early 'eighties, which helped bring about a revolution in photography.*

152 (OPPOSITE) *Mike Brearley, captain of the English cricket team in the late 'seventies, sported a helmet complete with perspex visor for the first time in 1979. This indicated the changing face of sport. Bowlers got faster and faster, with the consequent demise of the spin specialists.*

developed in the 'eighties, but were modified. Film speed dials were no longer needed because the films were encoded and the camera's computer operated in accordance with this information. Once the film speed dial had gone, it was inevitable that the next casualty would be the film. And, once the film went, so did the cameras. A new breed of electronic image recording cameras appeared to take the circular disc film. Kodak had taken half a step towards electronic films with their disc cameras, and Sony had been the first with their Mavica model (*Fig. 153*) which utilised electronic disc film. With a switch to electronic films, processing labs weren't needed, and there was large scale unemployment in this industry.

Professional photographers found themselves increasingly at risk. Not just because the electronic cameras were taking away a lot of their craft, but also because there was a new breed of amateur photo-

graphers who, because of the equipment, could get just as good results as the full-time pro.

Lenses became smaller, lighter and faster. Japanese research labs came up with a new range of optical intensifying plastic elements that consigned the lenses of the 'eighties into the museums by the early 1990s. Fixed focal lenses were useful only as paperweights (and weren't they heavy!) as zooms finally took over, despite the small band of pros who died off because they refused to accept them. Now, only one zoom is needed, covering everything from fisheye to super telephoto. Focal length is created by thought processes, with a manual override lever for those Monday morning blues.

Focusing is totally automated and infallible. All the photographer has to do is hold the camera, point it and select the focal length. And there's more than a few who have problems doing just that. Back in the 'eighties, the camera used to be the photographer's tool the means to an end – but now, the photographer is the camera's tool.

Much of the glamour went out of photography with the introduction of totally automatic cameras that produced instant prints. Because of the ease of taking perfectly exposed and sharp images, the technique of photography ceased to be a source of admiration to the average person and its use is now limited to specialist, low circulation magazines who regard it as an art form. There are very few professional photographers nowadays – about as many as there were painters and sculptors in the 'eighties. Most children now want to be television producers and programme editors.

It's said that there are still some photographers to be seen out with their old-fashioned 35 mm cameras, but they're very few and far between and generally regarded as eccentric.

154 *Carlos Reutemann before a Grand Prix. With faster and more dangerous cars, the man became less of an individual and more and more an extension of the machine.*

Index